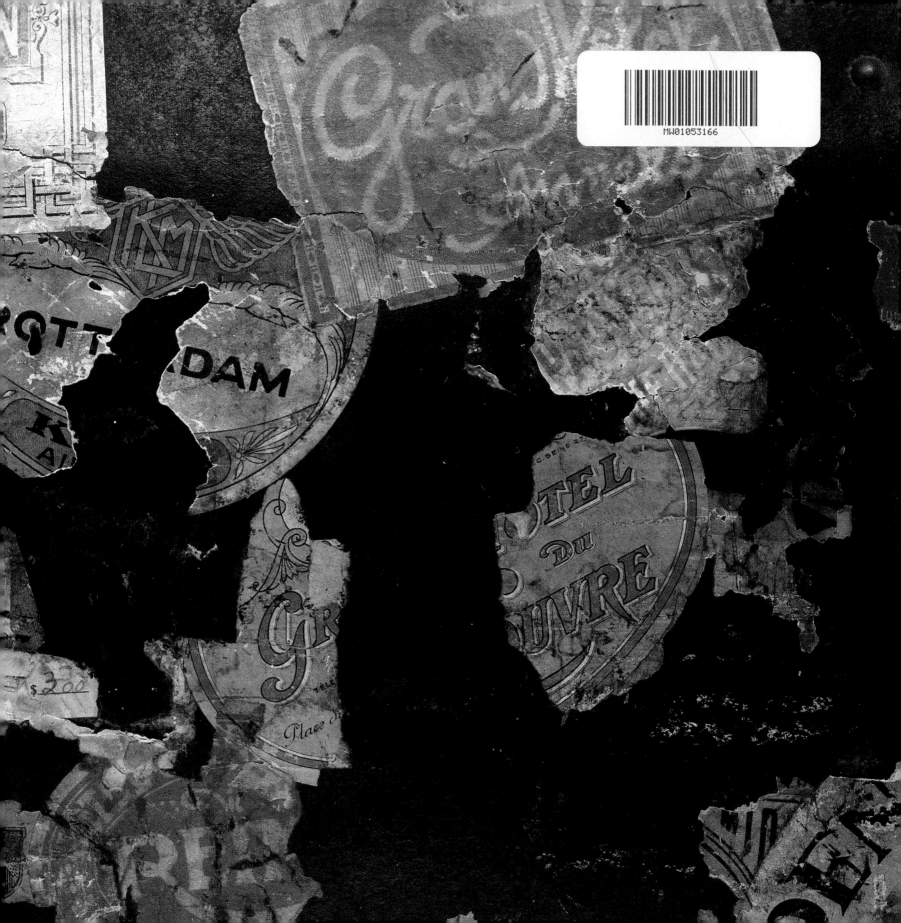

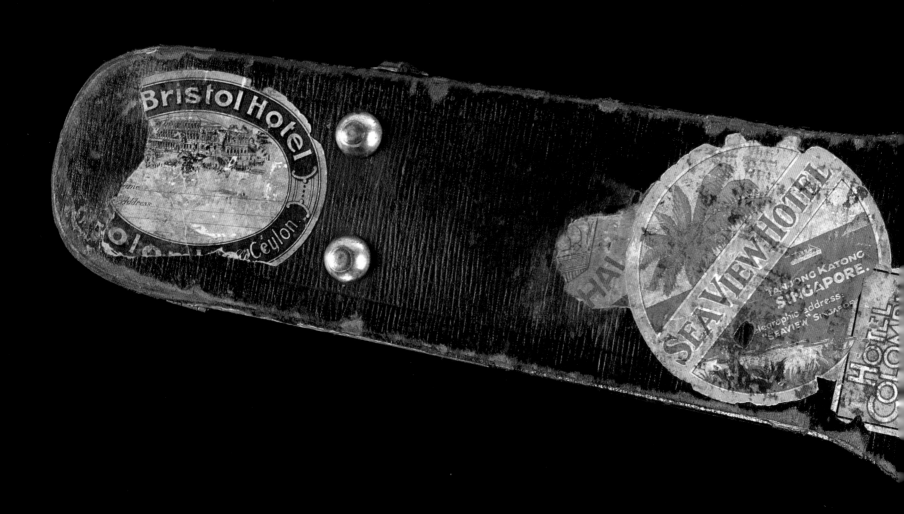

LUGGAGE LABELS

MEMENTOS FROM THE GOLDEN AGE OF TRAVEL

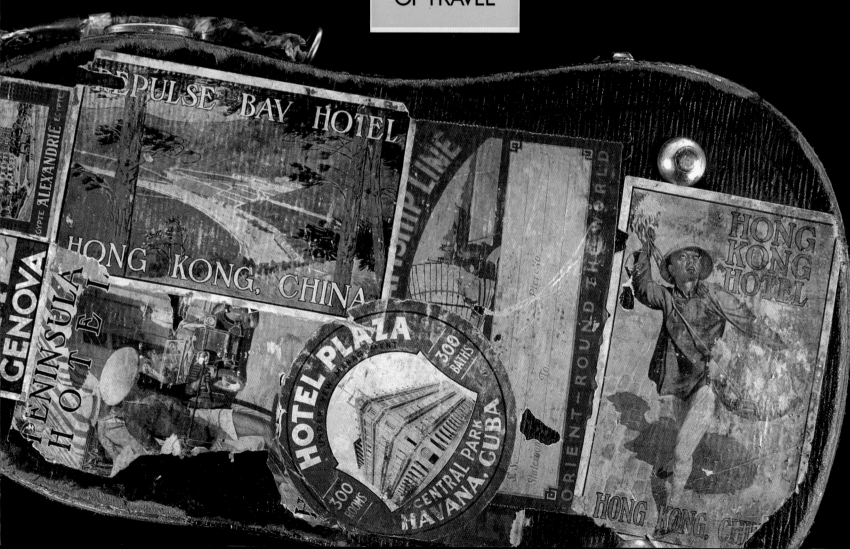

To my bold and patient traveling companions,
in appreciation of their good humor.

Library of Congress
Cataloging in Publication Data
Craig, David, 1951 –
Luggage labels: mementos from the golden
age of travel / David Craig; foreword by
Jan Morris.
p. cm.
Bibliography: p.
Includes index.
ISBN 0-87701-531-7 (pbk.)
1. Travel labels — Themes, motives. 1. Title.
NC1002.L3C74 1988 88-15338
741.67 — dc 19 CIP

Book and cover design:
Triad, San Rafael, California.

Printed in China

Distributed in Canada by Raincoast Books,
112 East Third Avenue, Vancouver, B.C.,
V5T IC8

10 9 8 7 6 5 4 3 2

Chronicle Books
275 Fifth Street
San Francisco, California 94103

Acknowledgments
I would like gratefully to acknowledge the
support and assistance of David Barich,
Lois Campbell, Brian Keller, Cynthia Tucker
Fordon, Nion McEvoy, William Rubel, Eliza
Sweetman, and Eve Wagner in assembling
this pictorial journey.

CONTENTS

FOREWORD

BY JAN MORRIS

Nothing heals a prejudice like the passage of time. Thirty years ago I cherished a sneering antipathy towards luggage labels, of the kind posh hotels used to give their guests to stick upon their suitcases. How pretentious, I used to think, how show-off, how nouveau riche! What vulgarly expensive trunks and hatboxes those stickers embellished, and with what preposterous calculation, I used to fancy, their owners displayed them for the benefit of envious passersby!

Two or three decades go by, and all is changed. That once ostentatious baggage is now shut away in attics. Those arrivistes are grey and sweet and living on their memories. And the labels I used to despise turn out to be fragrant with a nostalgic charm, besides being, now that I look at them more clearly and more closely, often remarkably beautiful.

Their predominant style, as one sees it in this collection, plainly dates them. They mostly come from the era that will always be remembered as the heyday of world tourism—the first half of the twentieth century, when pleasure travel was still leisurely, still ample, still for the most part by ship and railway, and still distinctly privileged. The labels identified a travelling class that was relatively small and socially cohesive. It was their survival into the egalitarian 1950s, I suppose, that raised my hackles against them: in their prime they were probably not pretentious at all, but were simply entertaining badges of membership.

Like most badges, they illustrated an ideal. In fact the hotels they advertised, the hotels represented in this book for instance, were seldom quite as perfect as they seemed on their emblems. The Pera Palace never did have that view of Istanbul. Shepheard's most certainly did not look out upon the Pyramids. Seldom was the water quite so serene around the Eastern and Oriental in Penang, and I doubt very much if the Boulevard de la Madeleine was ever quite so traffic-free as it appears in the label of the gloriously named Hôtel de Paris.

But then the labels also expressed aspirations, and these are far from discredited even now. A grand hotel is a grand hotel, as grand today as it ever was, and the particular aura that is projected by these lovely old stickers, the very essence of grand hoteldom, is still available to the more fortunate of travellers. Even now they may feel the very same glow of instant privilege, as they step across the portal of some really up-market, really urbane hotel, wedded less to trend than to style and tradition. They are unlikely to acquire such colourful mementos for their luggage, but still their stay in Ritz or Bristol, Palace or Majestic may leave memories just as happily erroneous: sunsets just as golden, prospects just as serene, ruins as meticulously picturesque, ever-pristine snows, and hotels at least as palatial as they look in the old labels—themselves so frayed and faded on Grandfather's leather portmanteaux up in the boxroom, but so delightfully revivified in the pages of this book.

VILLACH Kärnten

Hotel luggage labels made their appearance as the number of travelers—tourists, if you prefer—began its tremendous increase in the late nineteenth century. With the growth of tourism, and the unprecedented accessibility of foreign travel, a new age dawned for both travelers and travel-related businesses, including hotels. These hotel luggage labels are souvenirs of this grand age of travel, as well as personal mementos of the travelers who carried them home.

The advent of commercial tour packages, and the development of means of mass transportation such as railroads and enormous ocean steamers, increased the volume of travelers to the extent that providing accommodations was no longer merely the province of luxury hotel proprietors and modest and considerably less formal innkeepers. Thomas Cook, the British father of commercially organized excursions and corresponding means of marketing, began arranging trips in the 1840s. His maiden sojourn took six hundred souls from Leicester to Loughborough by rail for a temperance convention, and within a few years his enterprise was sending thousands of British and American citizens all around Europe, the British Isles, America, and the Holy Land. In the words of Mark Twain:

Cook has made travel easy and a pleasure. He will sell you a ticket to any place on the globe, or all the places, and give you all the time you need and much more besides. It provides hotels for you everywhere, if you so desire; and you cannot be over-charged, for the coupons show just how much you must pay. Cook's servants at the great stations will attend to your baggage, get you a cab, tell you how much to pay cabmen and porters, procure guides for you, and horses, donkeys, camels, bicycles, or anything else you want, and make life a comfort and satisfaction to you.

Travel, particularly for the Americans who brought home many of the labels collected in this book, represented (and still represents) an initiation, an opportunity to visit the places where their families used to live and see firsthand the cultures that inspired these new Americans to try something new. For those intent on escape and losing themselves, travel likewise presented the opportunity. Millions went abroad for purposes as varied as passing the time, becoming a more sophisticated and cosmopolitan person, finding a spouse with good testamentary prospects or a title to redeem the nouveau family fortune, submitting to legendary and miraculous regimens in order to fashion a new figure, soothing weak lungs and vague constitutional complaints, sowing wild oats with a minimum of family embarrassment, and finding freedom to express one's precious creative urges far from the philistines at home. And globe-trotting travelers still seek amusement, adventure, and social interaction.

Luggage labels are badges, emblems of their journeys. Battered labels encrusted on aged luggage can look very much like well-thumbed road maps, with each trunk displaying the

idiosyncratic geography of its owner, a personal world that took far longer than six days to create.

Many of the destinations of Cook's "grand circular tour of the Continent," first advertised in 1856 and popular well into the twentieth century, are represented in the following pages—Cologne, Baden-Baden, Frankfurt, Paris, London, Rome, Naples, and Venice. Nearly all of the places depicted in these labels are at least familiar, if not intimately well known, to armchair travelers who fearlessly embark for foreign ports of call by means of novels, newspaper travel columns, motion pictures, and television. The fame and reputation of these cities inspired hotel label designers, and in his 1930 travel memoir *Labels: A Mediterranean Journal*, Evelyn Waugh noted how well labeled they had become:

Now, Paris is a very well-known city—next to Rome, I suppose, the best-known in the world—and it is one which has come to bear all kinds of romantic labels for all kinds of people. I have called this book Labels *for the reason that all the places I visited on this trip are already fully labelled. I was no adventurer of the sort who can write books with such names as* Off the Beaten Track in Surrey *or* Plunges into Unknown Herts.

He describes Paris using an image that brings to mind the layers of peeling hotel labels seen on the bags of experienced travelers:

The characteristic thing about Paris is not so much the extent—though that is vast—as the overwhelming variety of its reputation. It has become so overlaid with successive plasterings of paste and proclamation that it has come to resemble those rotten old houses one sometimes sees during their demolitions, whose crumbling frame of walls is only held together by the solid strata of wall-papers.

Very little in the way of documentary history exists for these labels, other than passing references in histories of travel, advertising, luggage design, and similar works. The labels are like strangers sharing a passenger compartment or an airport lounge: each tells an individual story, in the context of the annals and apocrypha of its own time and place.

Typography, design, and printing can be used to estimate the dates of many labels, but most remain speculative, as designers tried to avoid elements that might too rapidly become unfashionably old-fashioned. The majority of the labels in this book are from the twentieth century; all display an astonishing and delightful mastery of style, ranging from ornate turn-of-the-century Art Nouveau, to Art Deco, streamlined Moderne, and International.

On occasion, the name of a hotel manager is a featured part of the label design, but most of the artists responsible for these engaging miniatures remain anonymous. As with a good deal of corporate image making, some hotels updated and redesigned their advertising graphics to be more in tune with changing styles. Other hotels maintained their thirties letter-forms and illustrations on luggage labels popular well into the early 1960s.

Historical events have left traces that aid in locating the labels in history. Careful readers will discover the dirigible *Hindenburg* in one of the German labels. War and political and social upheaval have altered the significance of labels for resorts and hotels located in places like Peking, Saigon, Beirut, and Dresden, while providing a basis for establishing their dates. Architecture, fashion, and vintage automobiles also place the illustrations in historical context.

Most of the labels originated with the hotels themselves, and their use was encouraged by the national agencies and offices established to promote tourism. National tourism offices began with the opening of the Italian agency in 1919; Italy's lead was quickly followed by Japan, as well as Switzerland, Belgium, Germany, and other European nations. Hotels sometimes sent labels to guests in advance, although the labels were primarily advertising tools rather than a means of routing luggage. Destinations were instead indicated by tags and stickers supplied by cruise ships, railroads, airlines, and other carriers, in a manner that is quite familiar to those who travel today.

The creators of pictorial luggage labels sought to distill in a very small space the pleasurable sensation of visiting the hotel. The labels attract, convince, charm, and reflect well on the taste and accomplishments of the guest whose luggage they bedeck. Many designers accomplished their tasks so well that favorite labels went into trunks and suitcases as souvenirs and mementos, rather than onto luggage as advertisements.

Thus, the labels (together with sketchbooks, diaries, readily purchased stereo views and picture postcards, as well as the increasingly popular photographic snapshot) were an integral part of one of the central mysteries of travel—telling the story of one's journey to those who stayed at home.

Designers made good use of the wide array of national and regional archetypes in concocting these shorthand visual messages. Architectural monuments and ruins, including Pisa's Leaning Tower, Gaudi's Cathedral of the Holy Family in Barcelona, the Parthenon, the Pyramids, and the Sphinx, made their way into scores of designs. Natural landmarks such as Vesuvius, the Matterhorn, and Mount Everest provided equally recognizable and dramatic visual elements. Dancers, characters in national dress, and exotic animals, such as tigers and elephants, appear on some of the more striking labels. For hoteliers who preferred labels that included a view of the premises, designers relied on distinctive color combinations, bold line, dramatic perspective, and unusual lighting to avoid making a dull impression.

The declining use of luggage labels is nearly as easy to explain as it is to demonstrate. The social and economic devastation of the Second World War, and subsequent recovery efforts, changed life significantly. When people resumed traveling for pleasure they were traveling lighter and more frequently, by means such as airplanes that both allowed and required less luggage. Modern luggage design and materials—soft suitcases, garment bags, and carry-ons of every description—leave no solid place for these thin, ephemeral ornamental labels. Owners of more traditional, often quite costly "designer" luggage are loath to obscure these credentials with additional labels. Photographs have replaced illustration in most travel advertising and journalism. Over the years, destinations and types of tours have changed. There is a move away from the well-labeled cities of the Grand Tour toward "away from it all" obscurity at resorts in economically underdeveloped countries, places affording favorable exchange rates and treks into semi-wilderness exotica that purport to deliver the same sensations as those experienced by truly daring explorers.

Though hotel luggage labels have all but disappeared in popular use, the lore of the label remains. It is a particular favorite of the illustrators of display ads in Sunday travel supplements and glossy tour brochures. All the attractive lures of the featured destinations are portrayed within the frames of an artful jumble of pseudo-labels on an oddly anachronistic piece of luggage. Sadly, all too few contemporary travelers are actually seen sporting these eccentric, conversation-starting portable collages. Nevertheless, in the world of travel illustration, labeled luggage still signifies a pending vacation.

No matter what form it takes, people still have impulses to use badges and emblems to communicate their status, exploits, and loyalties, and marketing professionals still understand the advertising opportunities these impulses provide. Just as medieval pilgrims adorned their garments with badges on their devotional journeys from shrine to shrine, so too does the modern traveler revel in displaying decorative signs and souvenirs. Hotel luggage labels are the venerable ancestors of state park and campground decals on automobiles and campers, embroidered patches on backpacks and ski parkas, and the thousands of designer labels and logos that have found their way from the inside to the outside of their owners' garments. Like the hotel labels that ended up in scrapbooks and diaries, modern stickers, decals, and patches turn up on surfaces not necessarily intended by their designers—school bags, skis, surfboards, guitar cases, motorcycles, and video and audio equipment. Taking further advantage of this trend, manufacturers of these highly visible "surfaces" now distribute their own decorative advertising stickers. Every surface that we wear or carry seems available for some form of politico-cultural signage. These ornamented items with which we travel are truly our baggage, so well described as *impedimenta*.

And the bags are packed, ready for your discovery. Sit back and relax for this journey through the peaks, valleys, cities, and landmarks captured on these small scraps of paper with such simple elegance and grand style.

Bon Voyage!

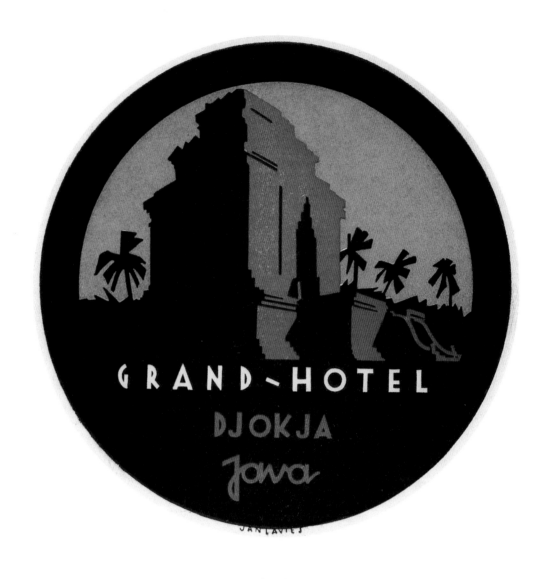

GRAND-HOTEL

DJOKJA

Jawa

Grand Hotel
Djokja (Djokjakarta), Indonesia

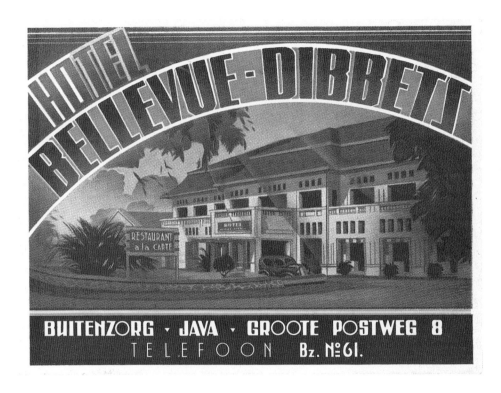

Hotel Bellevue-Dibbets
Buitenzorg (Bogor), Indonesia

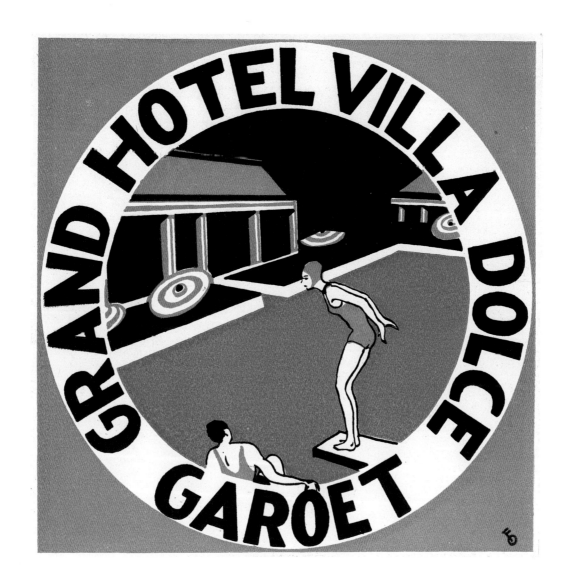

Grand Hotel Villa Dolce
Garoet (Garut), Indonesia

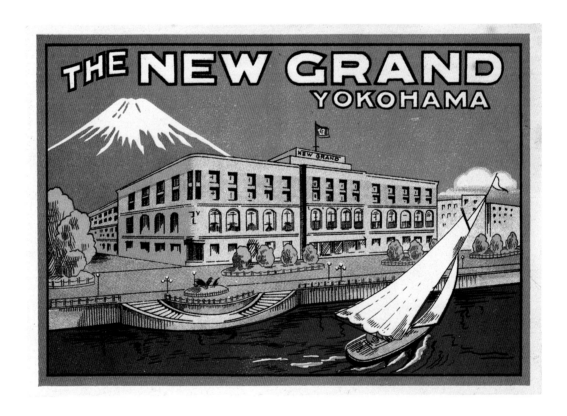

The New Grand
Yokohama, Japan

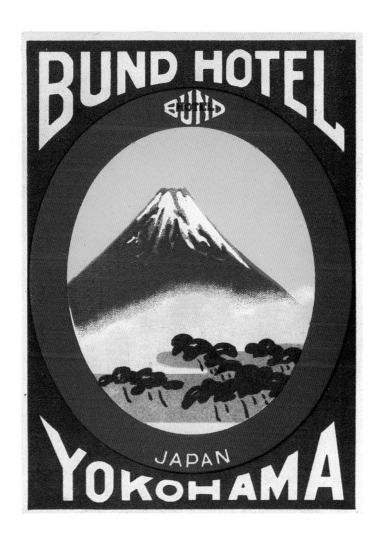

Bund Hotel
Yokohama, Japan

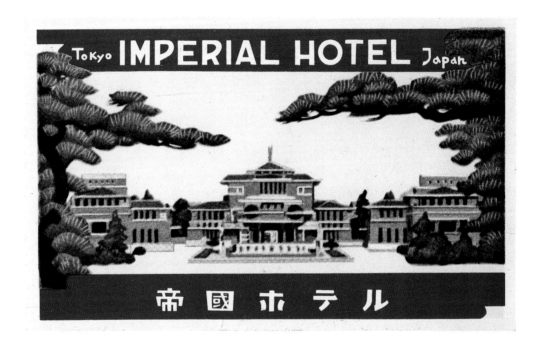

Imperial Hotel
Tokyo, Japan

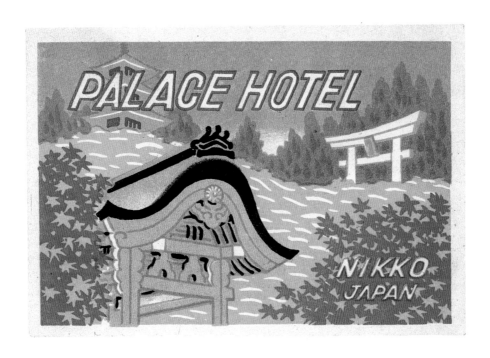

Palace Hotel
Nikko, Japan

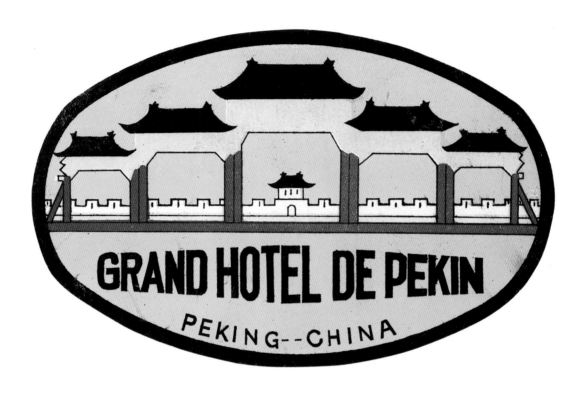

Grand Hôtel de Pekin
Peking (Beijing), China

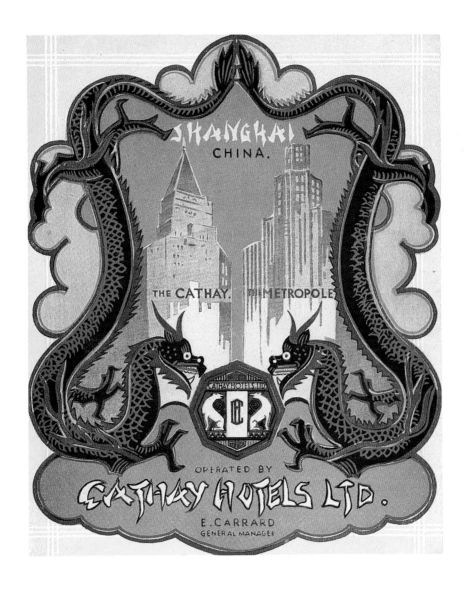

The Cathay and The Metropole
Shanghai, China

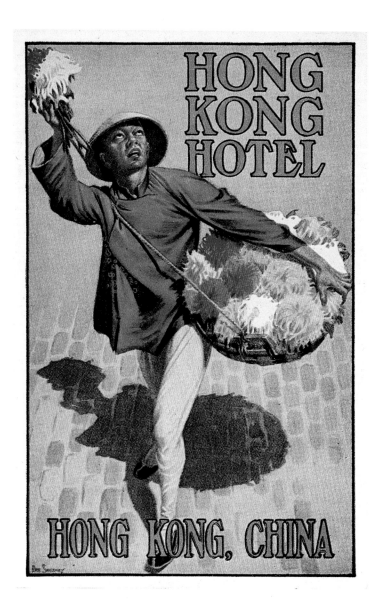

Hong Kong Hotel
Hong Kong

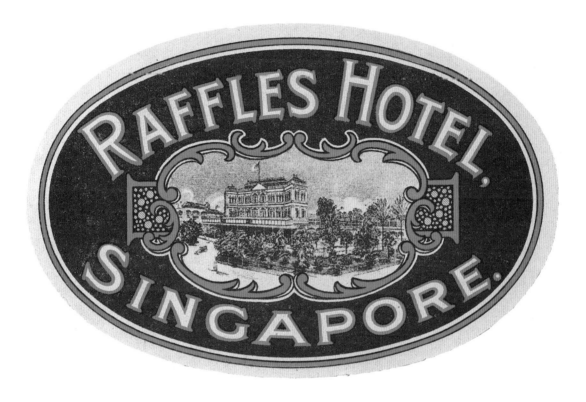

Raffles Hotel
Singapore

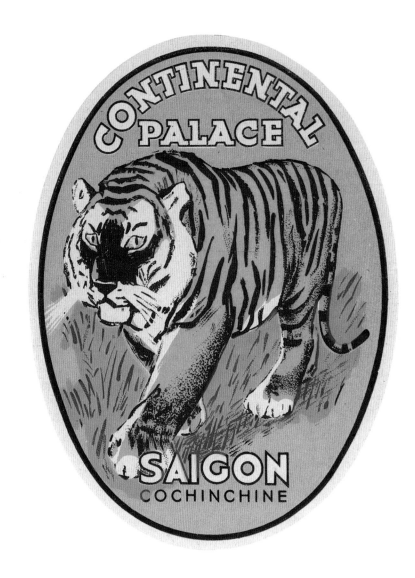

Continental Palace
Saigon (Ho Chi Minh City), Vietnam

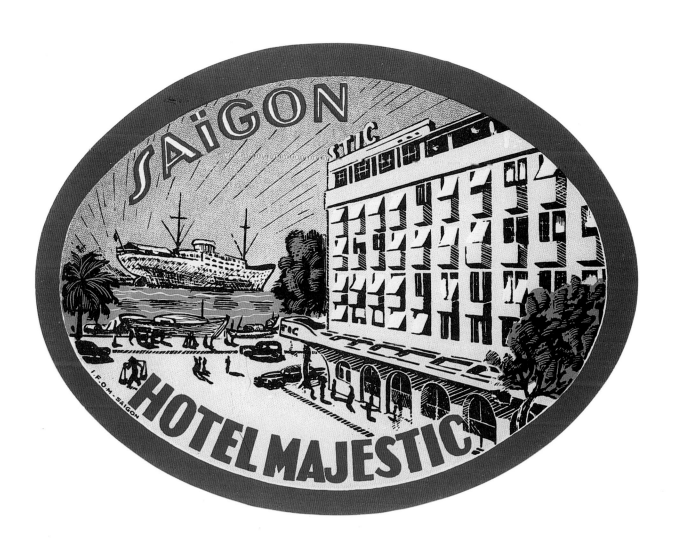

Hotel Majestic
Saigon (Ho Chi Minh City), Vietnam

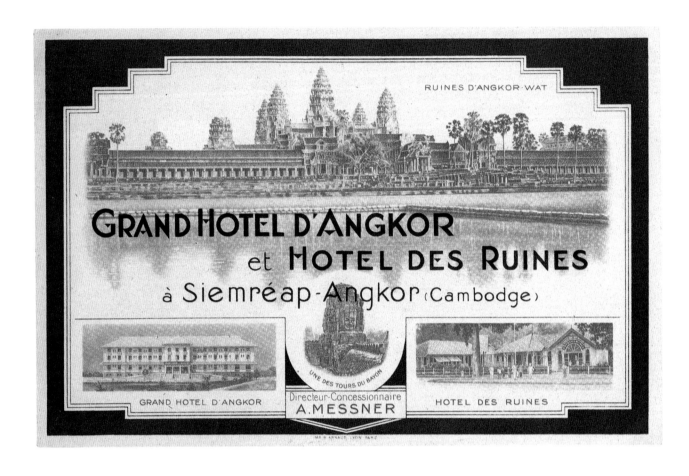

Grand Hôtel d'Angkor and Hôtel des Ruines
Angkor Wat, Kampuchea

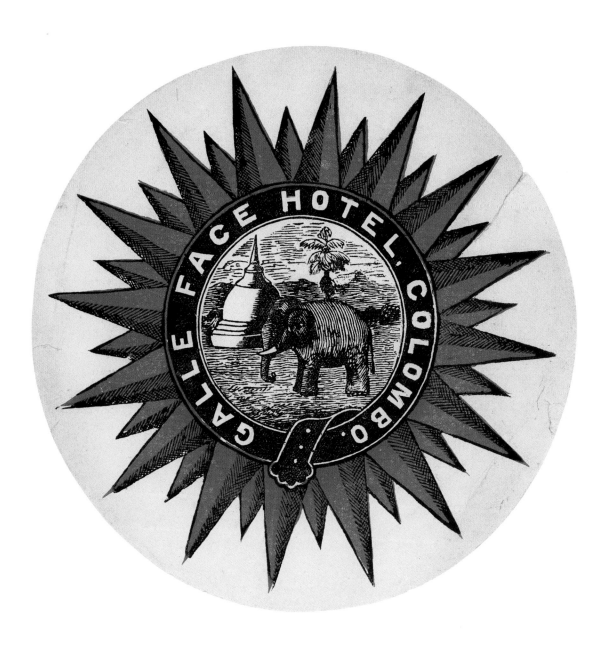

Galle Face Hotel
Colombo, Sri Lanka

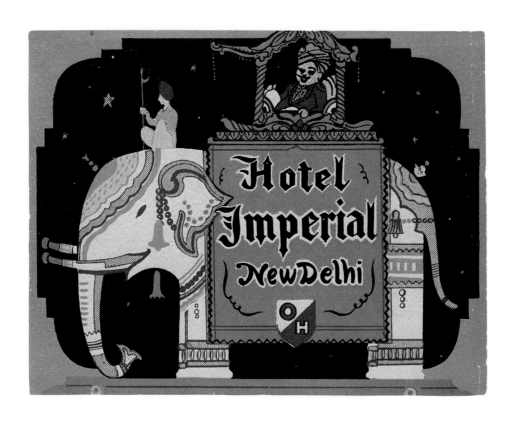

Hotel Imperial
New Delhi, India

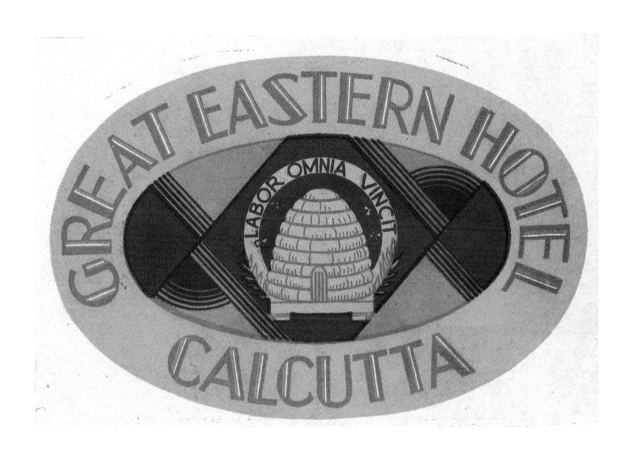

GREAT EASTERN HOTEL

LABOR OMNIA VINCIT

CALCUTTA

Great Eastern Hotel
Calcutta, India

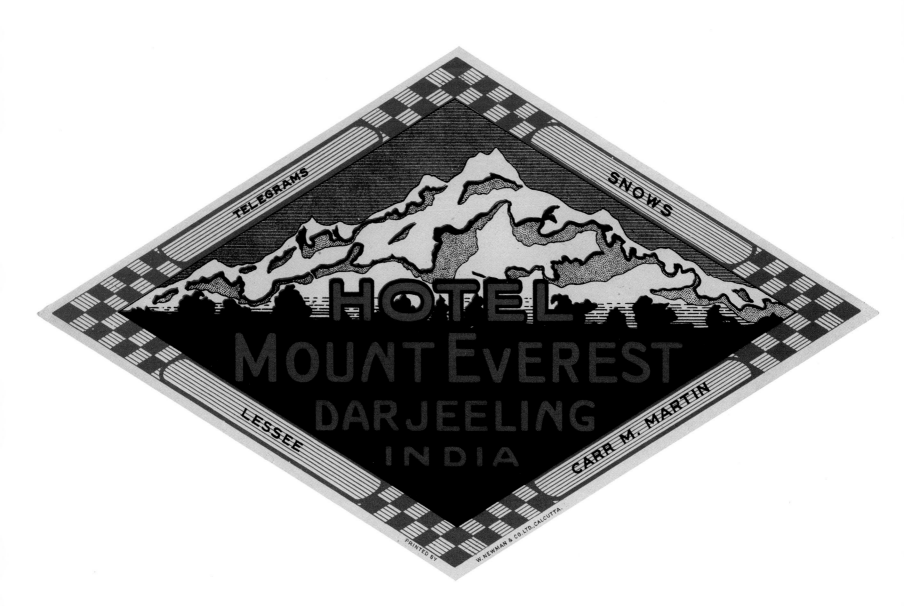

Hotel Mount Everest
Darjeeling, India

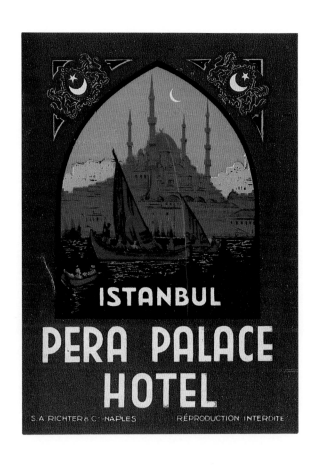

ISTANBUL

PERA PALACE HOTEL

S.A. RICHTER & C.-NAPLES RÉPRODUCTION INTERDITE

Pera Palace Hotel
Istanbul, Turkey

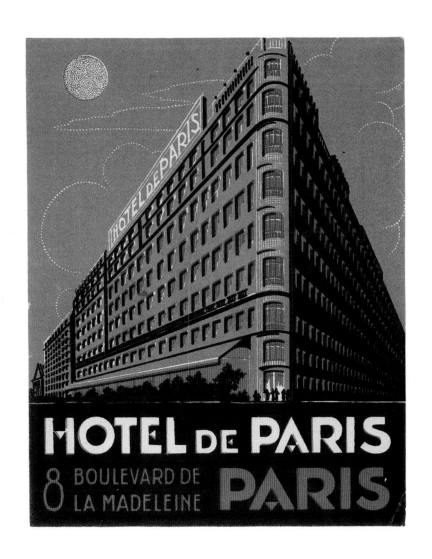

Hôtel de Paris
Paris, France

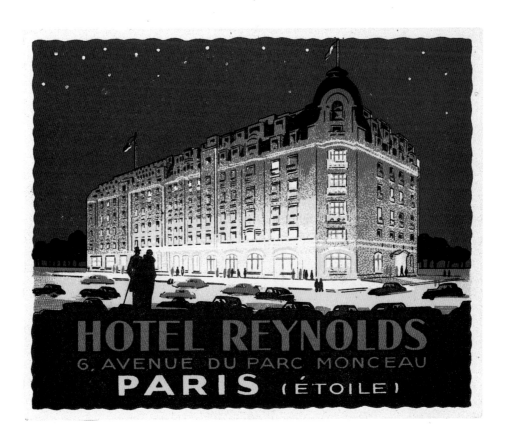

Hôtel Reynolds
Paris, France

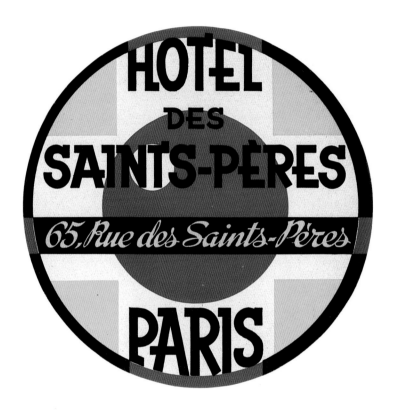

Hôtel des Saints-Pères
Paris, France

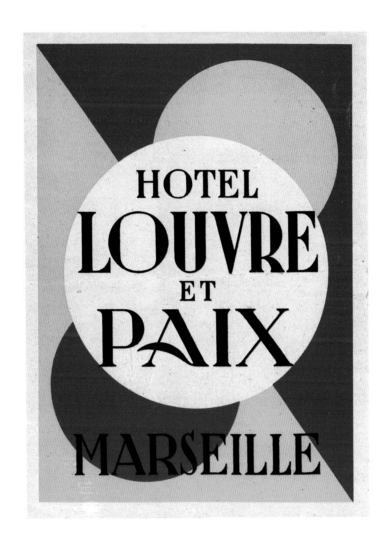

Hôtel Louvre et Paix
Marseille, France

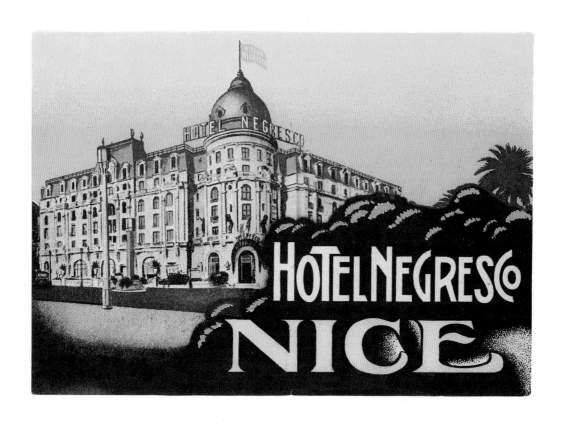

Hôtel Negresco
Nice, France

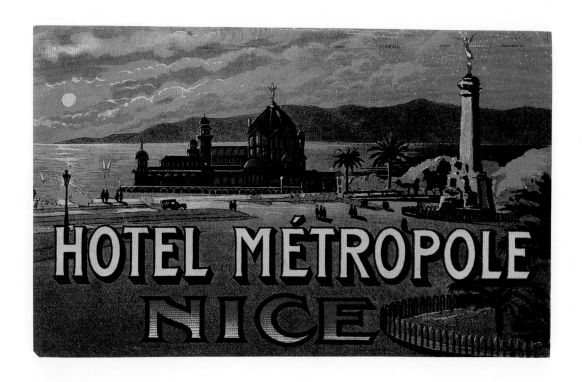

Hôtel Métropole
Nice, France

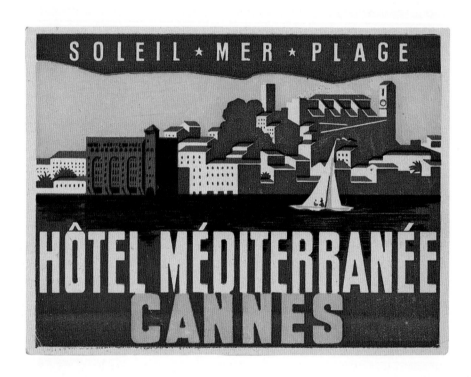

Hôtel Méditerranée
Cannes, France

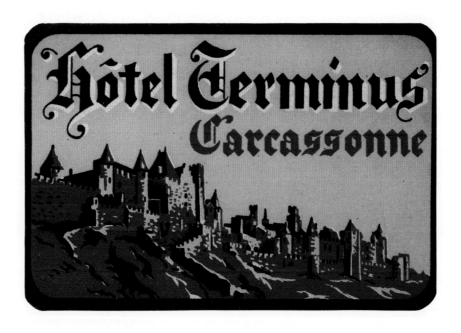

Hôtel Terminus
Carcassonne, France

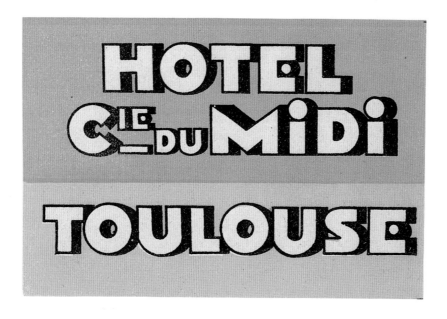

Hôtel de la Compagnie du Midi
Toulouse, France

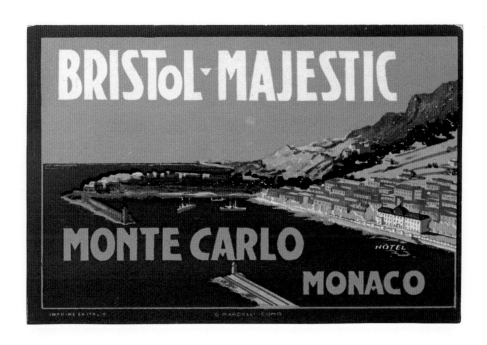

Bristol-Majestic
Monte Carlo, Monaco

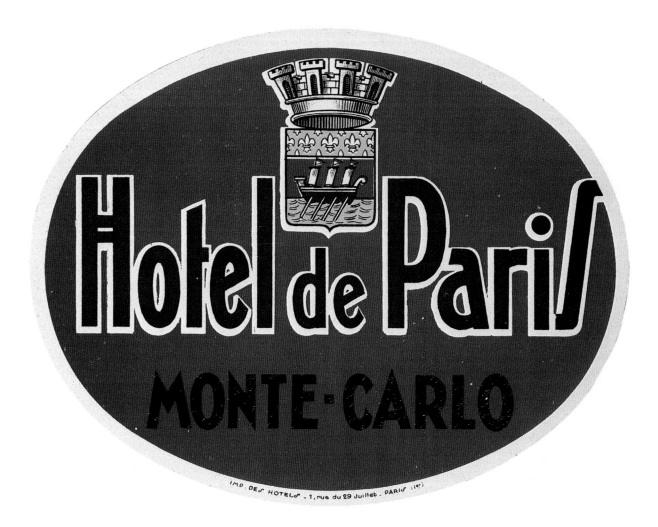

Hôtel de Paris
Monte Carlo, Monaco

42

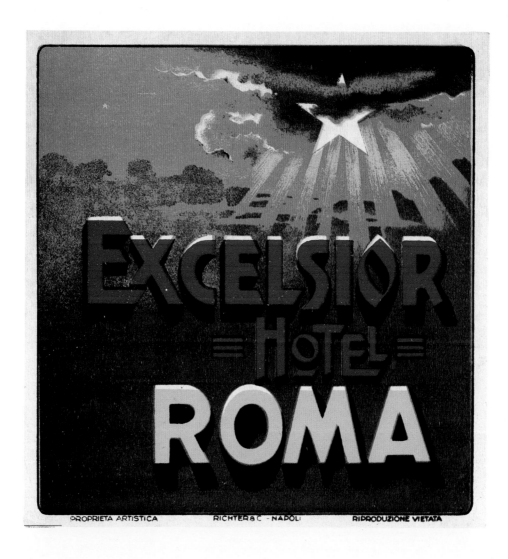

Excelsior Hotel
Rome, Italy

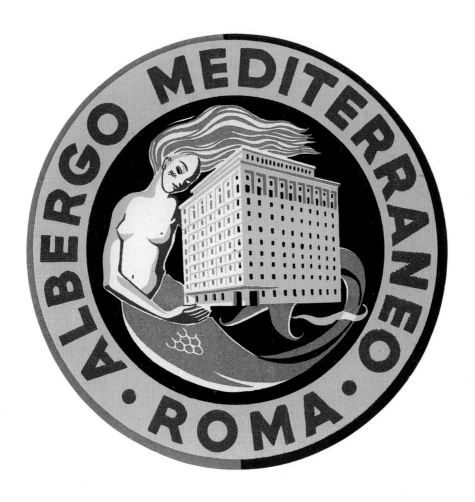

Albergo Mediterraneo
Rome, Italy

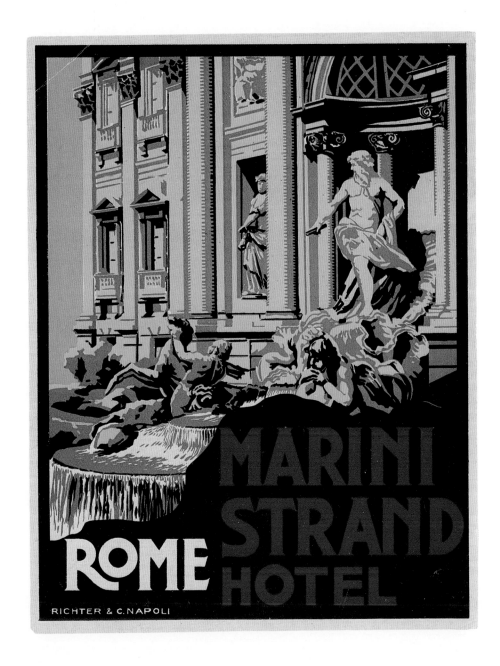

Marini Strand Hotel
Rome, Italy

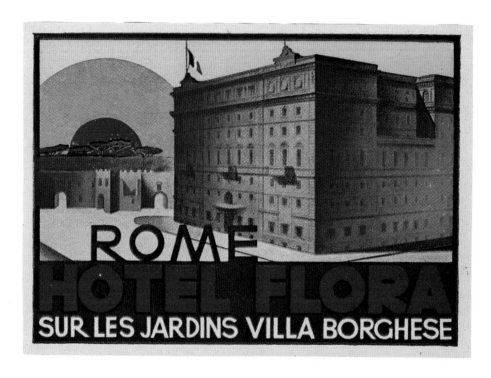

Hotel Flora
Rome, Italy

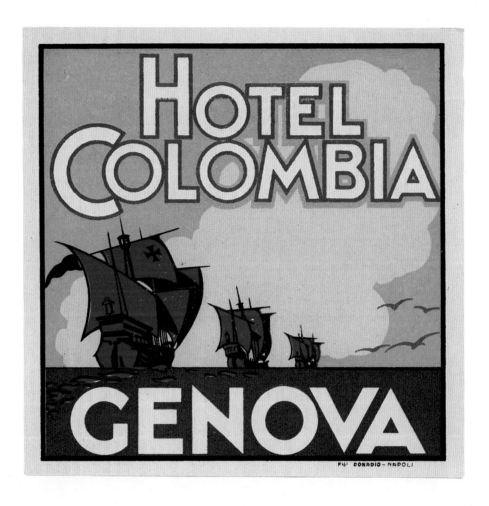

Hotel Colombia
Genoa, Italy

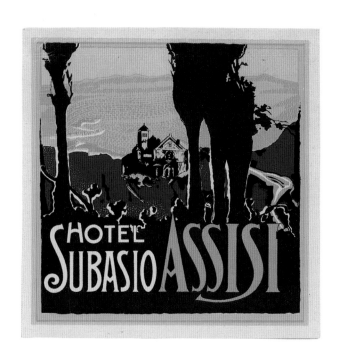

Hotel Subasio
Assisi, Italy

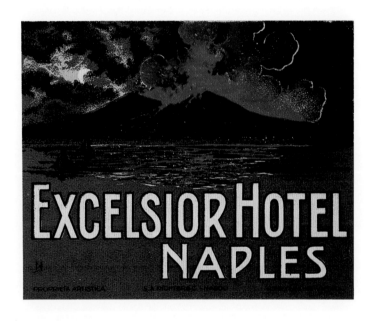

Excelsior Hotel
Naples, Italy

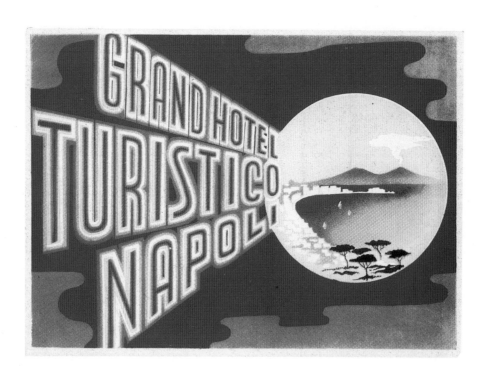

Grand Hotel Turistico
Naples, Italy

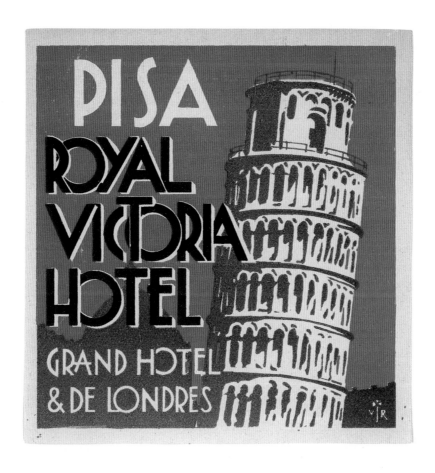

Royal Victoria Hotel
Pisa, Italy

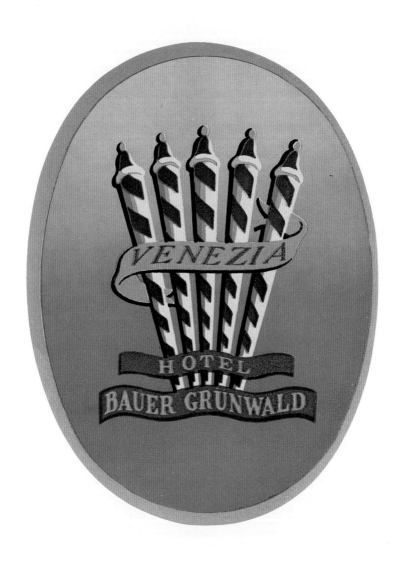

Hotel Bauer Grünwald
Venice, Italy

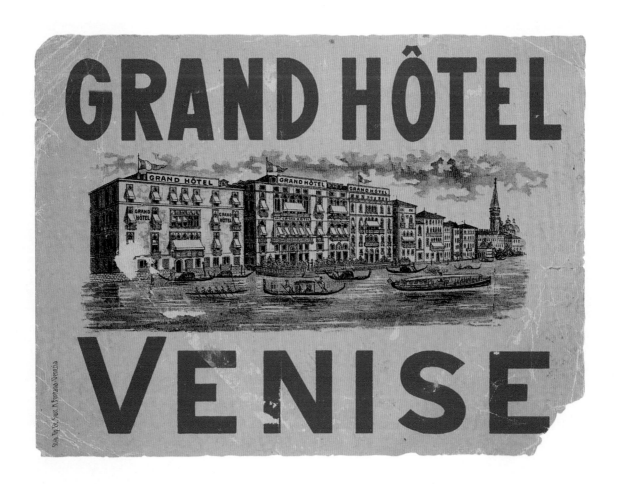

Grand Hôtel
Venice, Italy

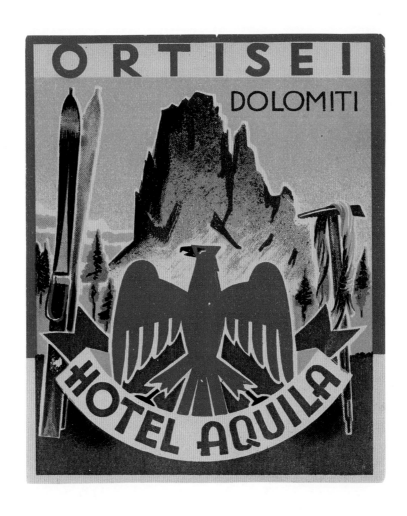

Hotel Aquila
Ortisei, Italy

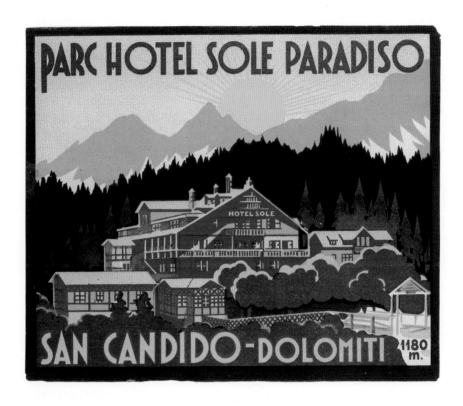

Parc Hotel Sole Paradiso
San Candido, Italy

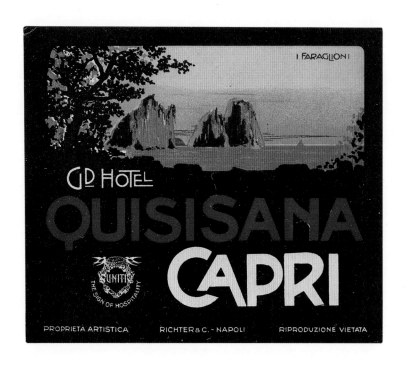

Grand Hotel Quisisana
Capri, Italy

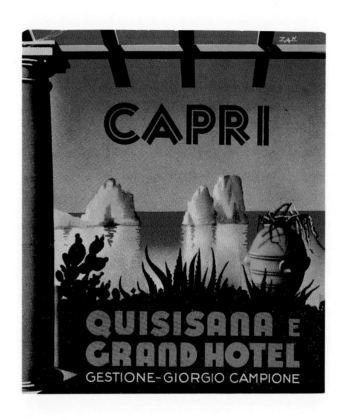

Grand Hotel Quisisana
Capri, Italy

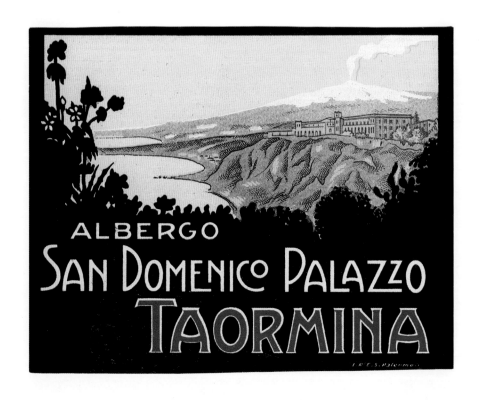

Albergo San Domenico Palazzo
Taormina, Italy

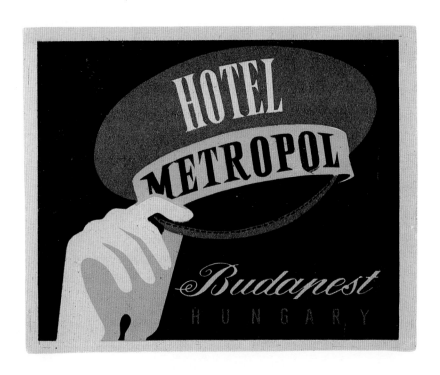

Hotel Metropol
Budapest, Hungary

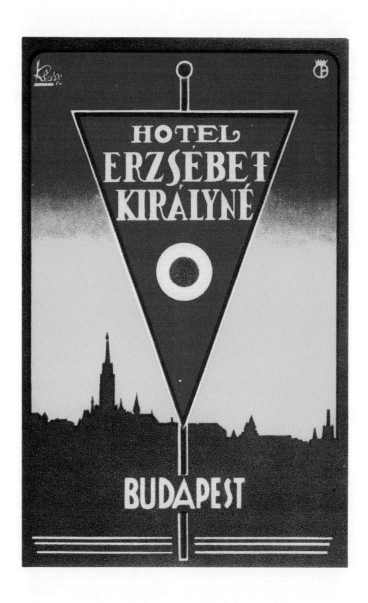

Hotel Erzsébet Királyné
Budapest, Hungary

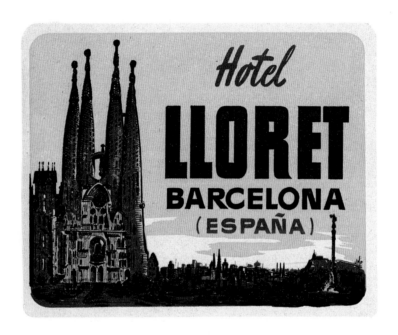

Hotel Lloret
Barcelona, Spain

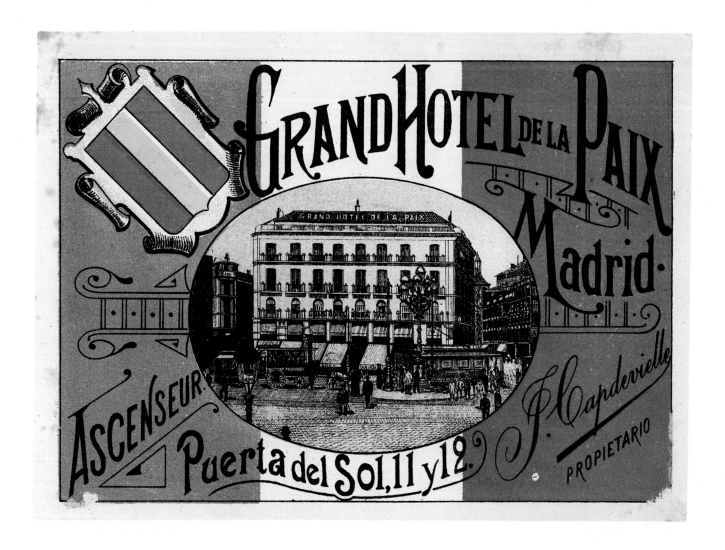

Grand Hôtel de la Paix
Madrid, Spain

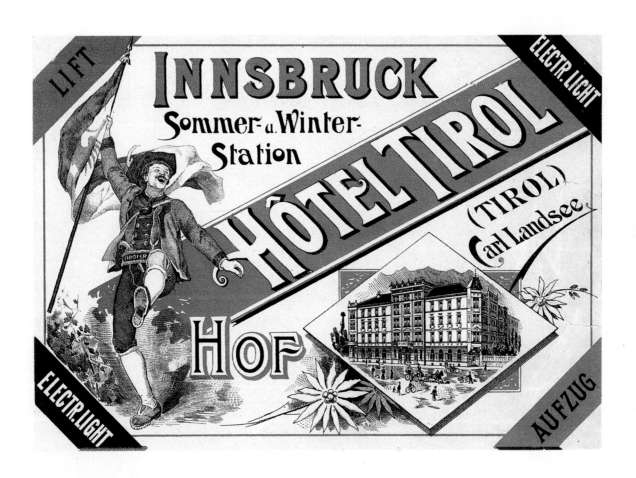

Hôtel Tirol
Innsbruck, Austria

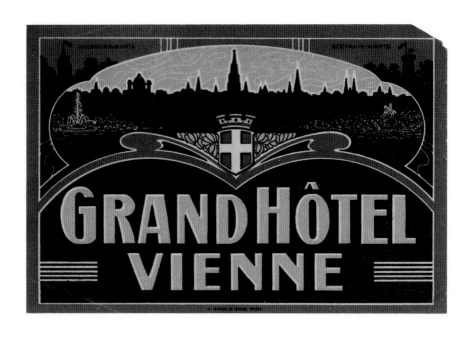

Grand Hôtel
Vienna, Austria

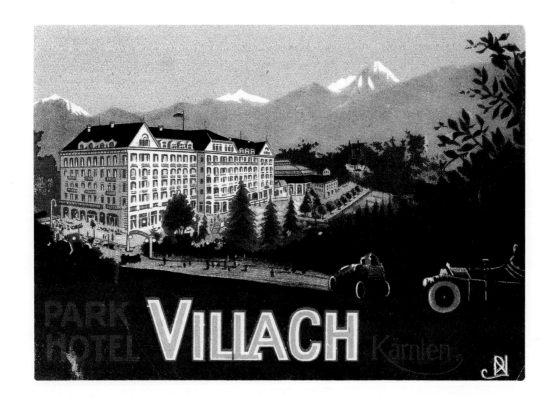

Parkhotel Kärnten
Villach, Austria

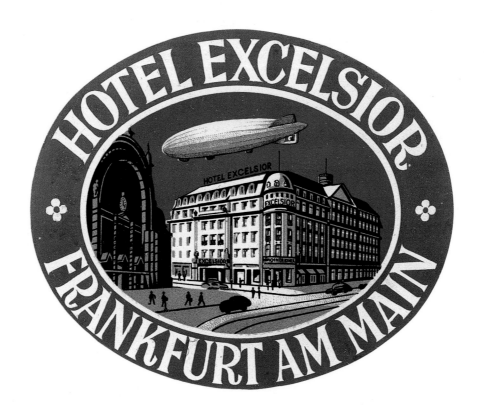

Hotel Excelsior
Frankfurt, West Germany

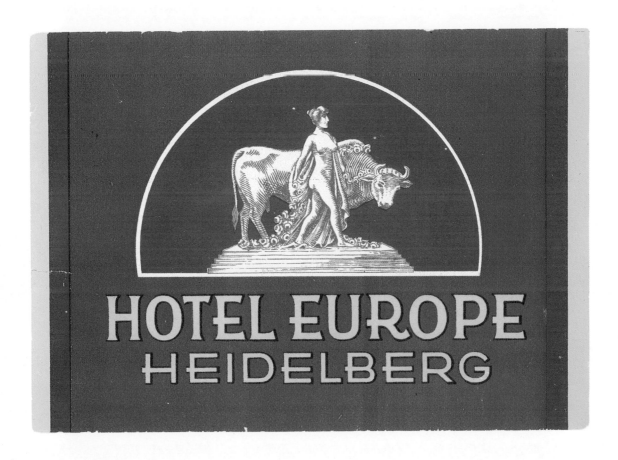

Hotel Europe
Heidelberg, West Germany

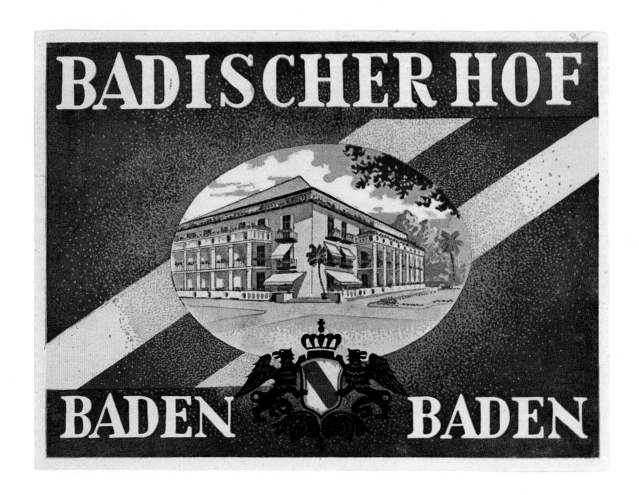

Badischer Hof
Baden-Baden, West Germany

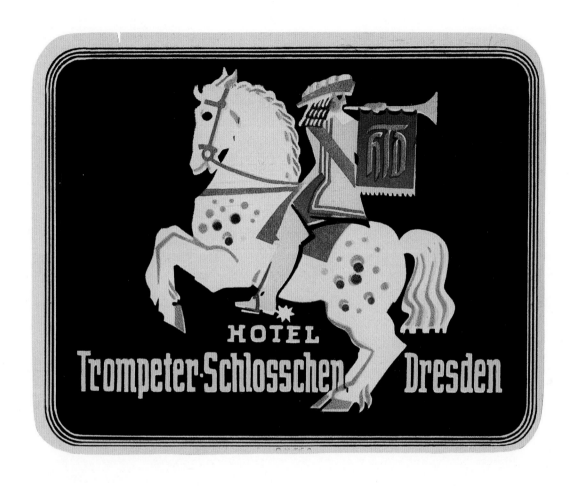

Hotel Trompeter-Schlosschen
Dresden, East Germany

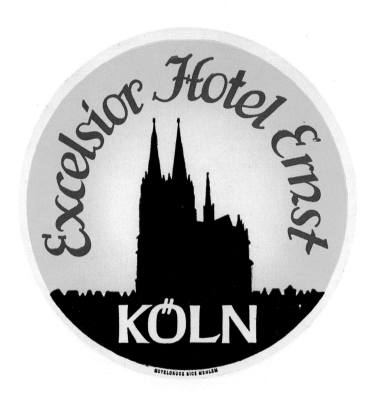

Excelsior Hotel Ernst
Cologne, West Germany

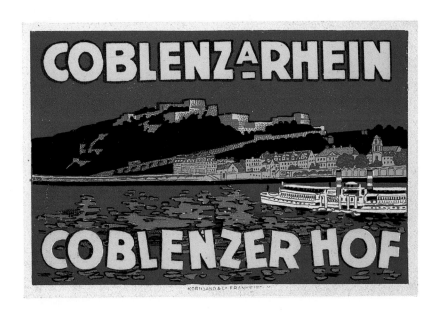

Coblenzer Hof
Koblenz, West Germany

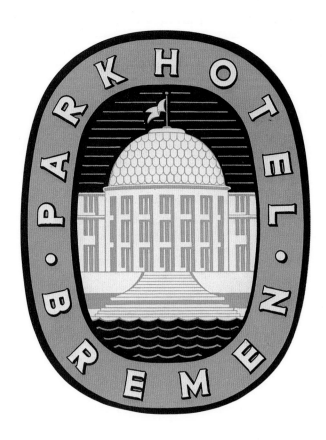

Park Hotel
Bremen, West Germany

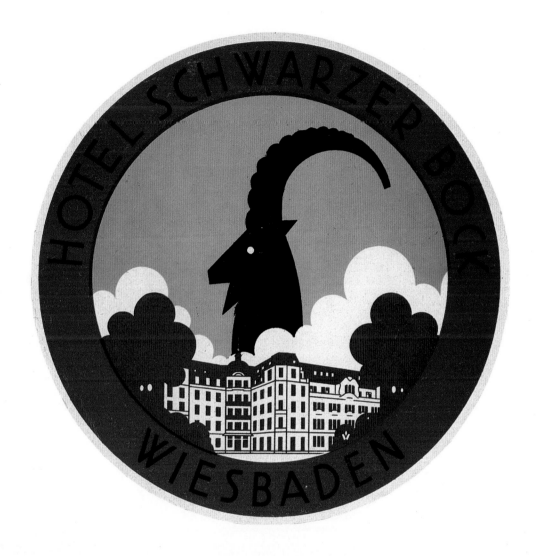

Hotel Schwarzer Bock
Wiesbaden, West Germany

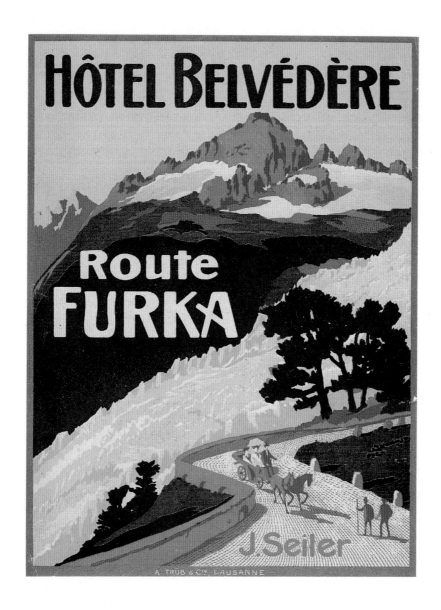

Hôtel Belvédère
Furka Pass, Switzerland

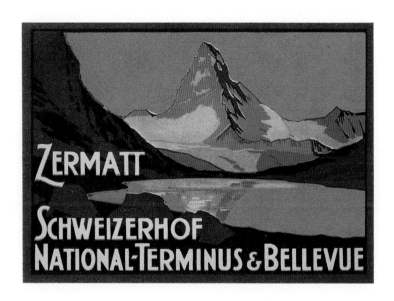

Hotel Schweizerhof
Zermatt, Switzerland

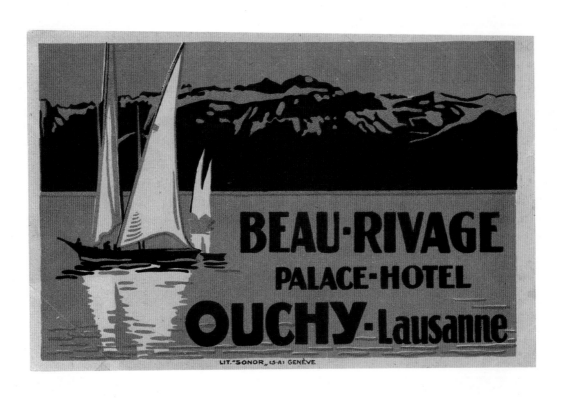

Beau-Rivage Palace-Hotel
Lausanne-Ouchy, Switzerland

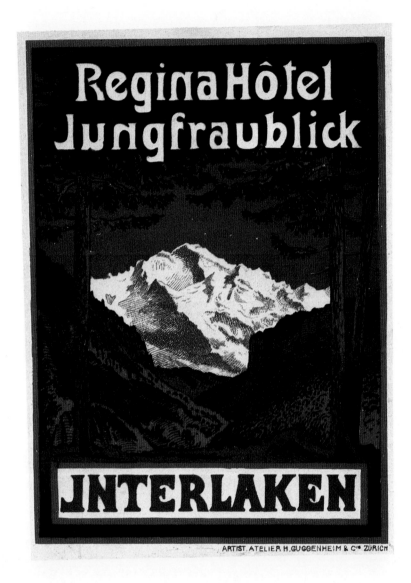

Regina Hôtel Jungfraublick
Interlaken, Switzerland

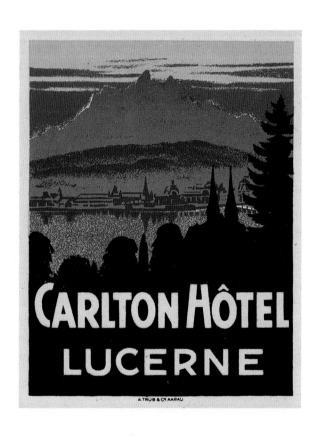

Carlton Hôtel
Lucerne, Switzerland

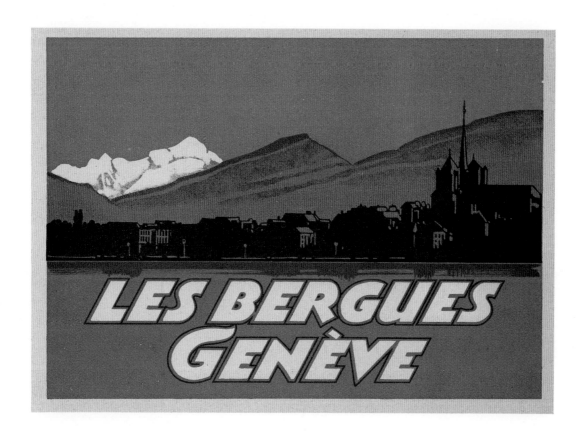

Hôtel des Bergues
Geneva, Switzerland

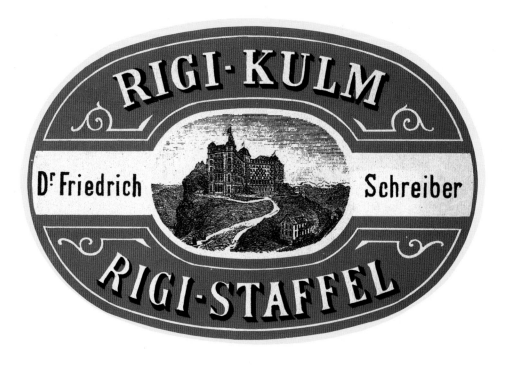

Hotel Rigi-Kulm
Rigi-Kulm, Switzerland

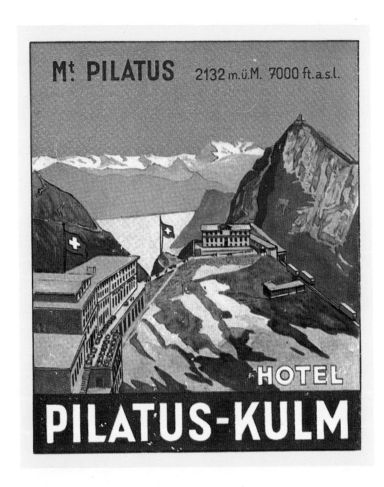

Hotel Pilatus-Kulm
Mt. Pilatus, Switzerland

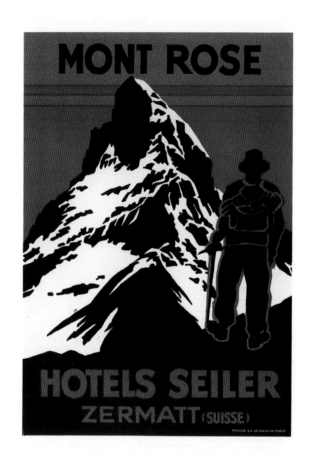

Hotel Monte Rosa
Zermatt, Switzerland

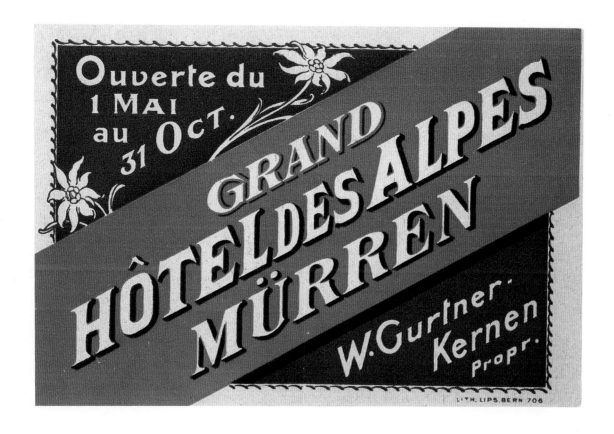

Grand Hôtel des Alpes
Mürren, Switzerland

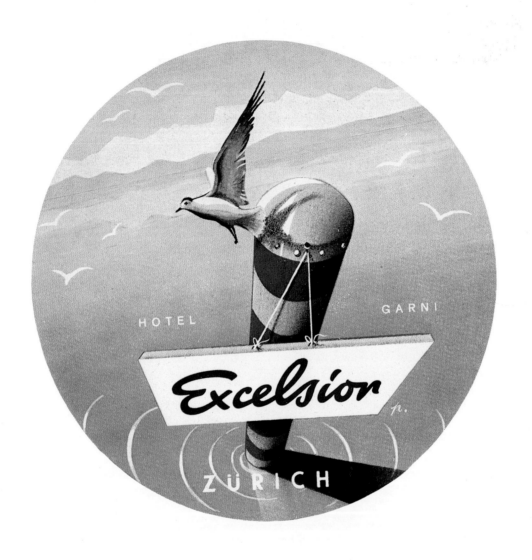

Hotel Excelsior
Zurich, Switzerland

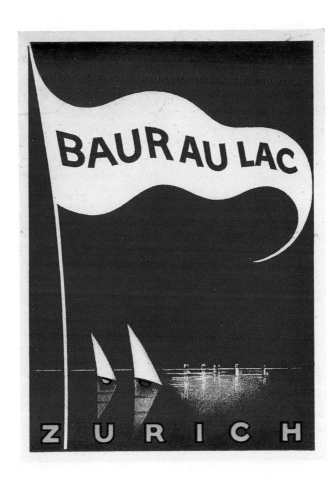

Hôtel Baur au Lac
Zurich, Switzerland

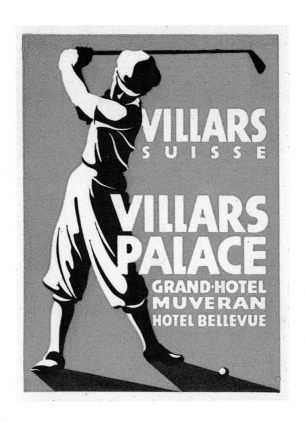

Villars Palace
Villars, Switzerland

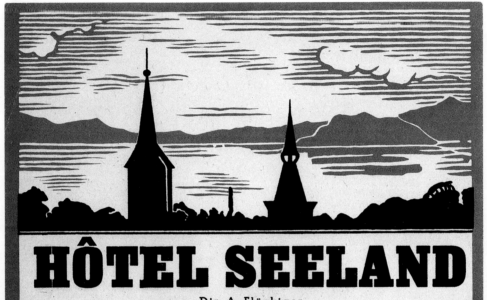

Hôtel Seeland
Biel, Switzerland

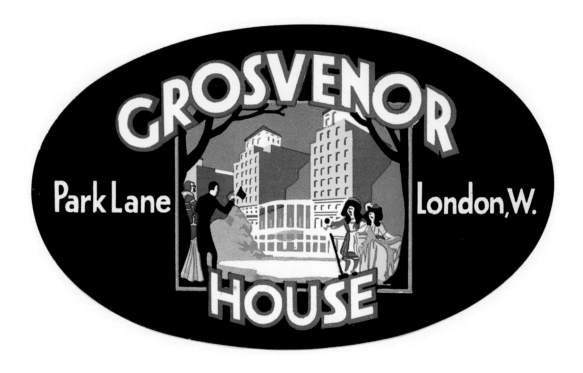

Grosvenor House
London, England

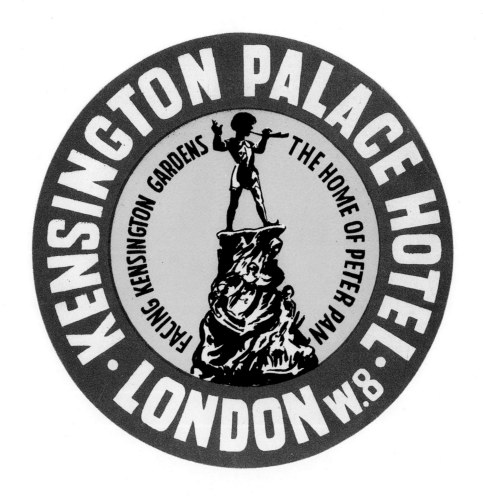

KENSINGTON PALACE HOTEL • LONDON W.8

FACING KENSINGTON GARDENS

THE HOME OF PETER PAN

Kensington Palace Hotel
London, England

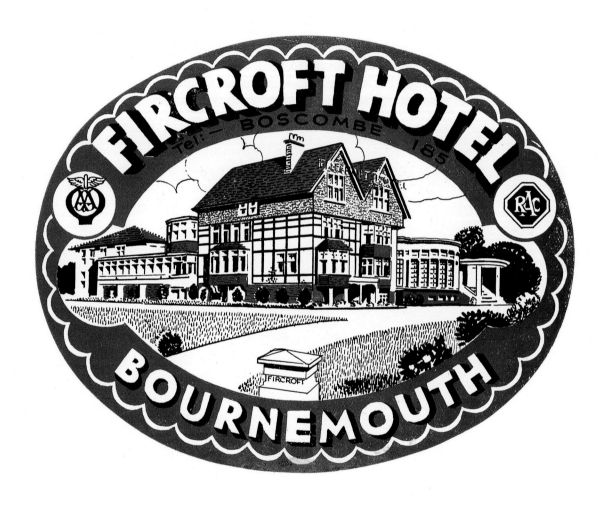

Fircroft Hotel
Bournemouth, England

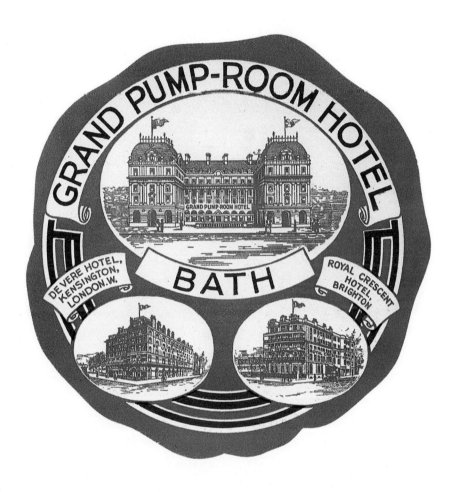

Grand Pump-Room Hotel
Bath, England

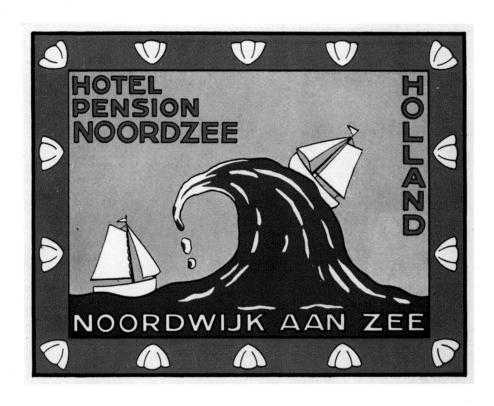

Hotel Pension Noordzee
Noordwijk aan Zee, The Netherlands

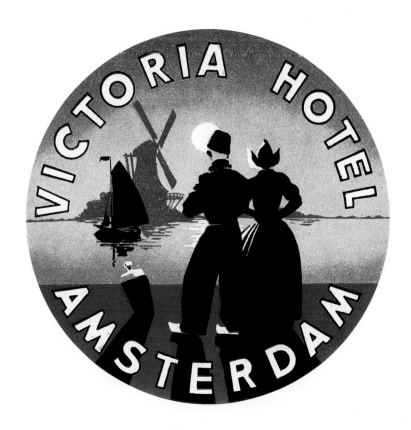

Victoria Hotel
Amsterdam, The Netherlands

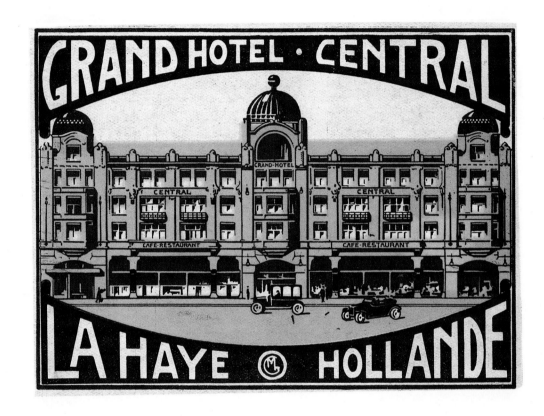

Grand Hotel-Central
The Hague, The Netherlands

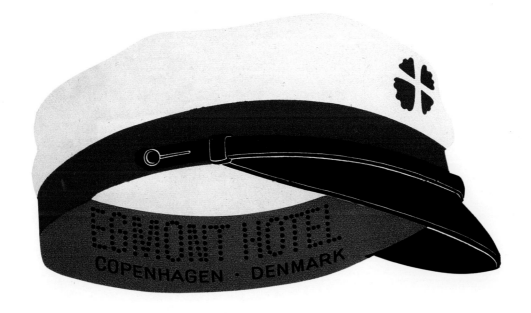

Egmont Hotel
Copenhagen, Denmark

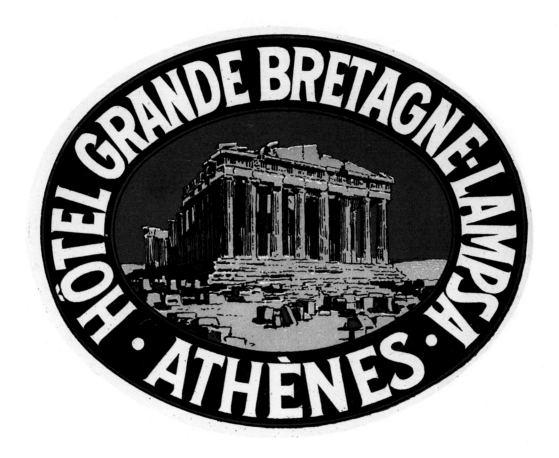

Hôtel Grande Bretagne
Athens, Greece

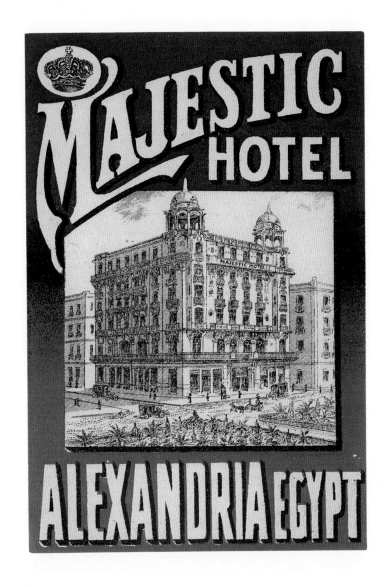

Majestic Hotel
Alexandria, Egypt

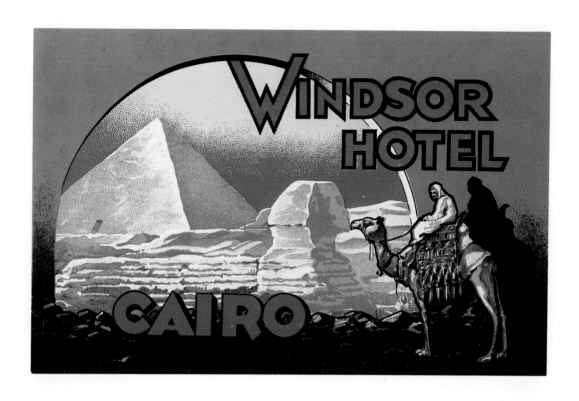

Windsor Hotel
Cairo, Egypt

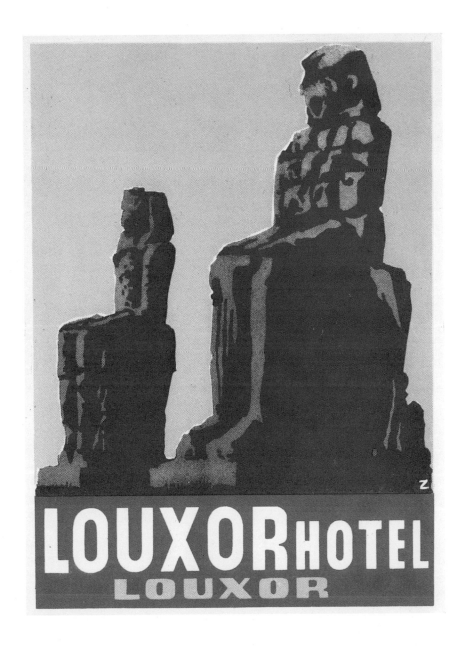

Louxor Hotel
Luxor, Egypt

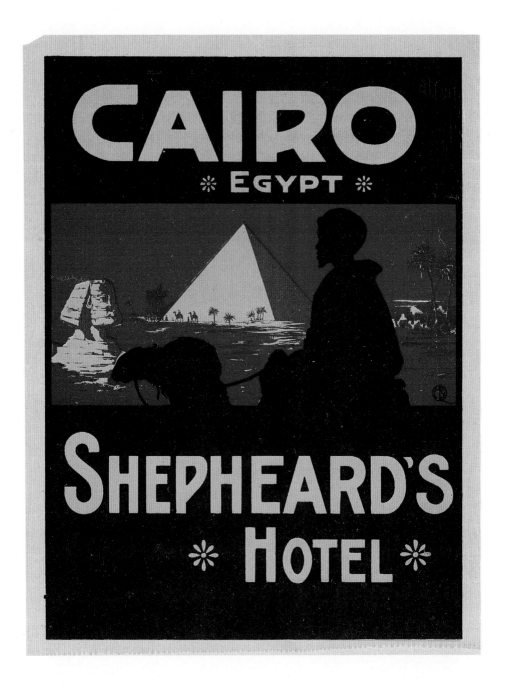

Shepheard's Hotel
Cairo, Egypt

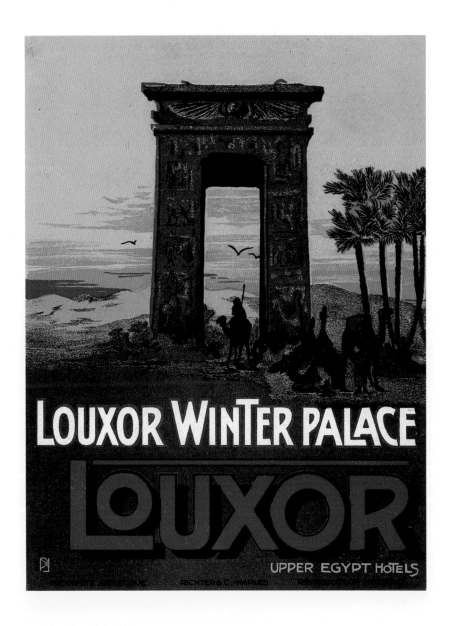

Louxor Winter Palace
Luxor, Egypt

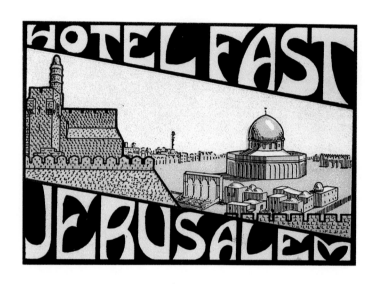

Hotel Fast
Jerusalem, Israel

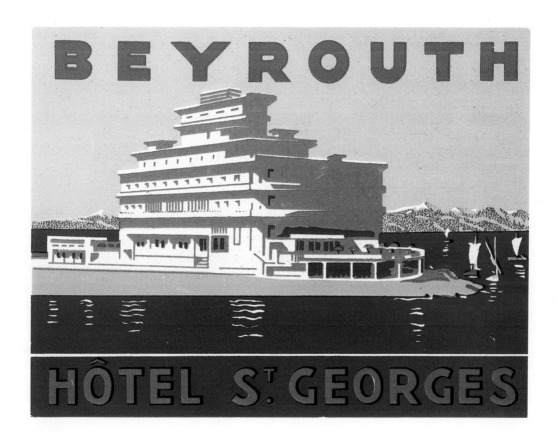

Hôtel St. Georges
Beirut, Lebanon

103

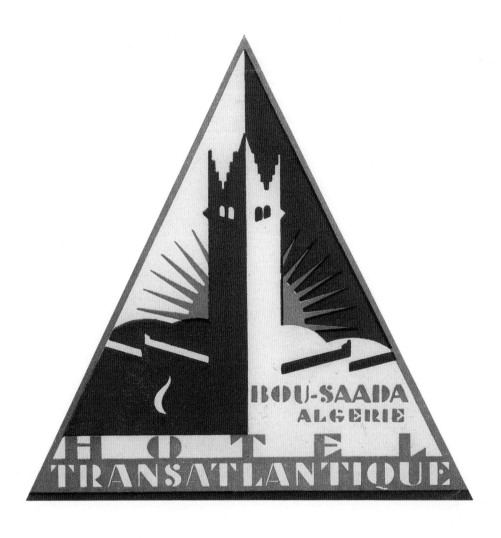

Hôtel Transatlantique
Bou Saâda, Algeria

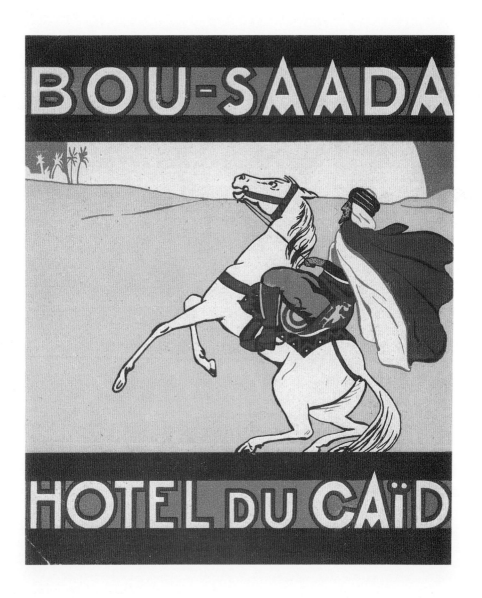

Hôtel du Caïd
Bou Saâda, Algeria

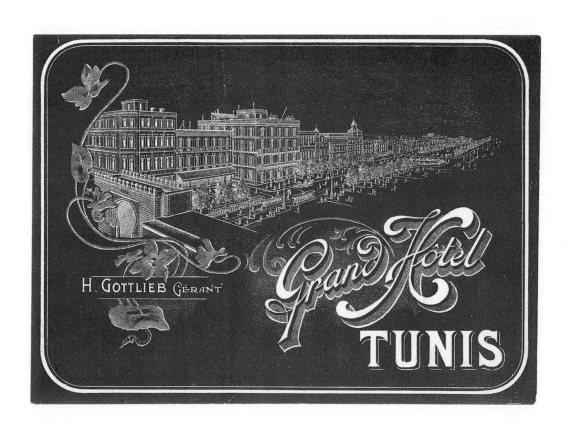

Grand Hôtel
Tunis, Tunisia

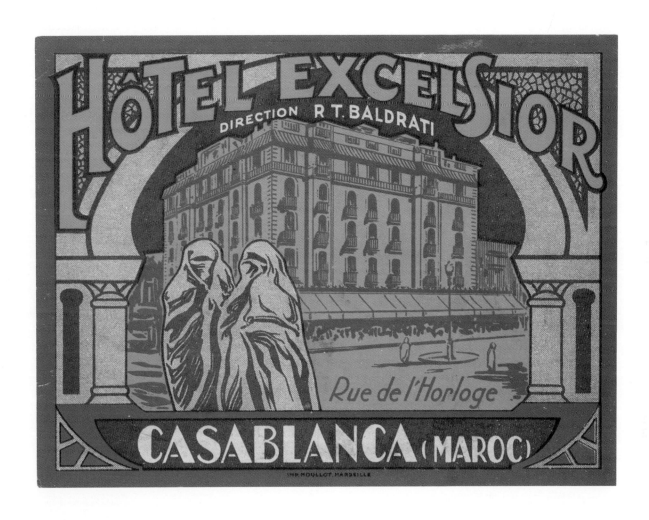

Hôtel Excelsior
Casablanca, Morocco

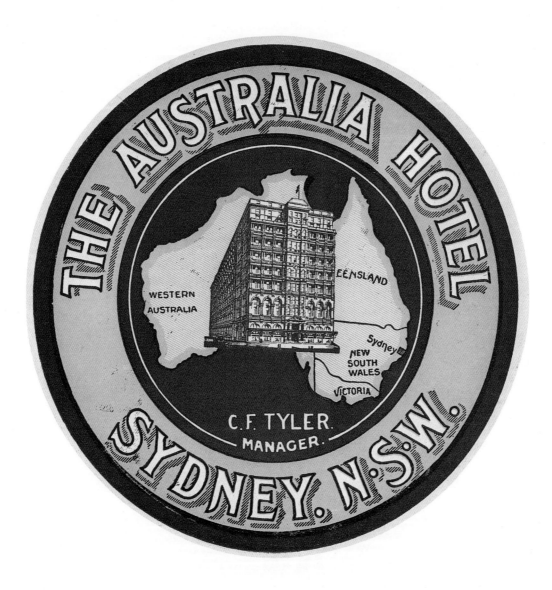

The Australia Hotel
Sydney, Australia

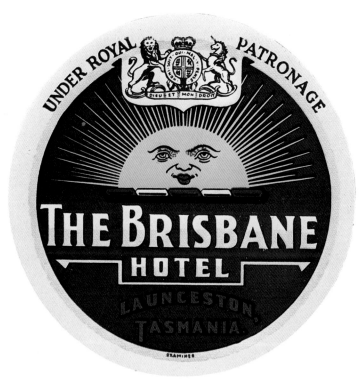

The Brisbane Hotel
Launceston, Australia

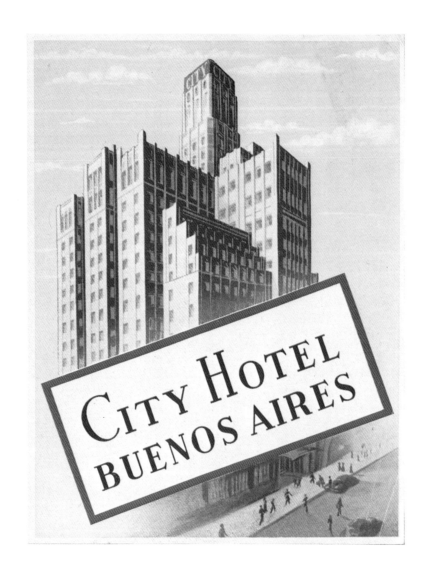

City Hotel
Buenos Aires, Argentina

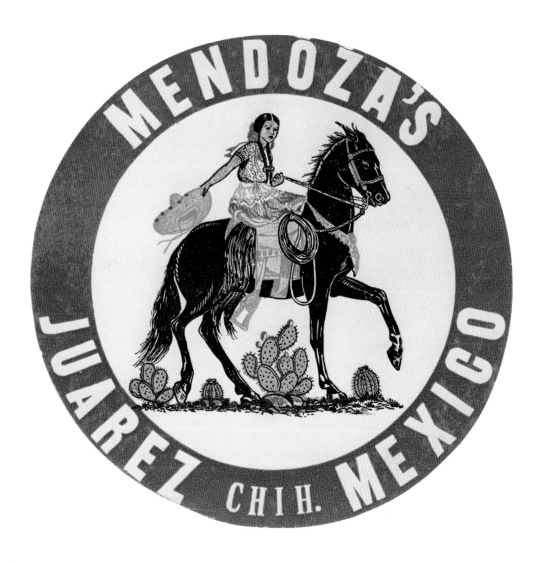

Mendoza's
Ciudad Juarez, Mexico

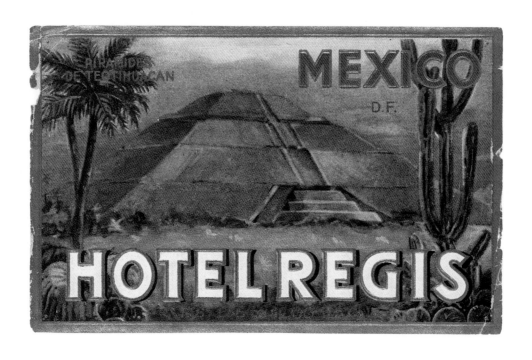

Hotel Regis
Mexico City, Mexico

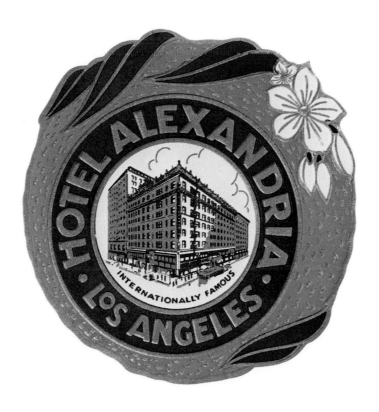

Hotel Alexandria
Los Angeles, United States

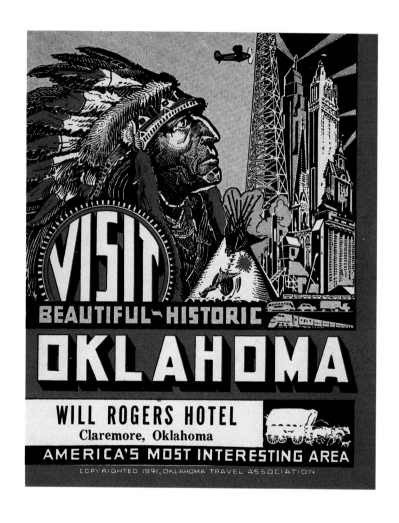

Will Rogers Hotel
Claremore, United States

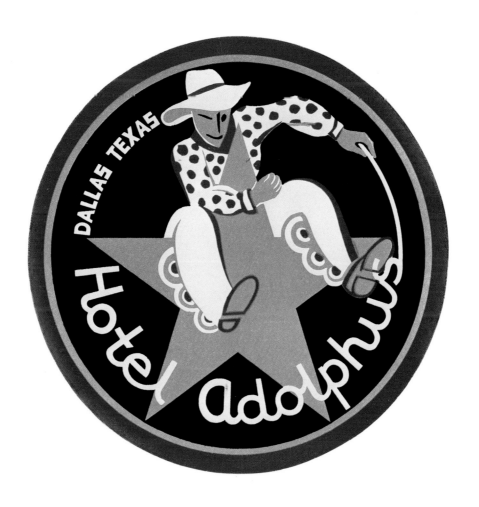

Hotel Adolphus
Dallas, United States

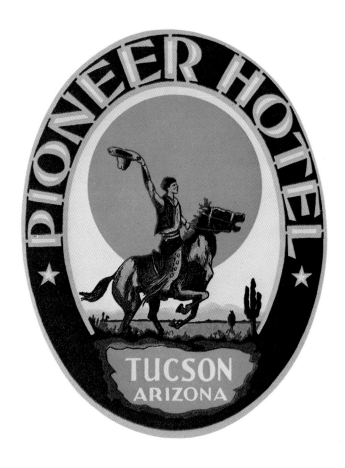

Pioneer Hotel
Tucson, United States

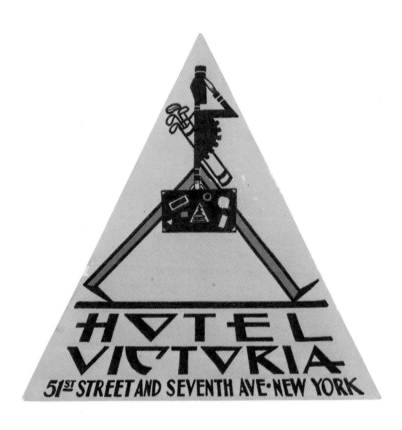

Hotel Victoria
New York, United States

BIBLIOGRAPHY

Anderson, Janice, and Swinglehurst, Edmund. *Ephemera of Travel & Transport*. London: New Cavendish Books, 1981.

Bird, Nicky. *Luggage Labels from the Great Age of Shipping*. London: The Victoria and Albert Museum, 1985.

Boorstin, Daniel J. "From Traveler to Tourist: The Lost Art of Travel," *The Image or What Happened to the American Dream*. New York: Atheneum, 1962.

Davis, Alec. *Package and Print: The Development of Container and Label Design*. New York: Clarkson N. Potter, Inc., 1967.

Dulles, Foster Rhea. *Americans Abroad: Two Centuries of European Travel*. Ann Arbor: The University of Michigan Press, 1964.

Feifer, Maxine. *Tourism in History: From Imperial Rome to the Present*. New York: Stein and Day, Inc., 1985.

Frischauer, Willi. *The Grand Hotels of Europe*. New York: Coward-McCann, Inc., 1965.

Gaspard, M. "Étiquette," *Publimondial: Special Graphique*, no. 48, Paris, 1953.

Humbert, Claude. *Label Design*. Fribourg: Office du Livre, 1972.

Links, J.G.; Fussell, Paul; and others. *Bon Voyage: Designs for Travel*. (Prepared in conjunction with an exhibition at the Cooper-Hewitt Museum, sponsored by Louis Vuitton, Inc.) New York, Cooper-Hewitt Museum: The Smithsonian Institution's National Museum of Design, 1986.

Matthew, Christopher. *A Different World: Stories of Great Hotels*. New York and London: Paddington Press, 1976.

Meade, Martin; Fitchett, Joseph; and Lawrence, Anthony. *Grand Oriental Hotels from Cairo to Tokyo, 1800–1939*. New York: The Vendome Press, 1987.

Opie, Robert. *The Art of the Label*. London: Quarto Publishing (Chartwell Books, Inc.), 1987.

Owen, Charles. *The Grand Days of Travel*. Exeter: Windward/Webb & Bower Ltd., 1979.

Palin, Michael. *Happy Holidays: The Golden Age of Railway Posters*. London: Pavilion Books Limited in association with Michael Joseph Limited, 1987.

Swinglehurst, Edmund. *Cook's Tours: The Story of Popular Travel*. Dorset: Blandford Press, 1982.

Swinglehurst, Edmund. *The Romantic Journey: The Story of Thomas Cook and Victorian Travel*. New York: Harper & Row, Publishers, Inc., 1974.

Watkin, David, and others. *Grand Hotel, The Golden Age of Palace Hotels: An Architectural and Social History*. New York: The Vendome Press, 1984.

Waugh, Evelyn. *Labels: A Mediterranean Journal*. London: Duckworth, 1930.

Grand Hotel; Djokja (Djokjakarta), Indonesia; 13

Hotel Bellevue-Dibbets; Buitenzorg (Bogor), Indonesia; 14

Grand Hotel Villa Dolce; Garoet, Indonesia; 15

The New Grand; Yokohama, Japan; 16

Bund Hotel; Yokohama, Japan; 17

Imperial Hotel; Tokyo, Japan; 18

Palace Hotel; Nikko, Japan; 19

Grand Hôtel de Pekin; Peking (Beijing), China; 20

The Cathay and The Metropole; Shanghai, China; 21

Hong Kong Hotel; Hong Kong; 22

Raffles Hotel; Singapore; 23

Continental Palace; Saigon (Ho Chi Minh City), Vietnam; 24

Hotel Majestic; Saigon (Ho Chi Minh City), Vietnam; 25

Grand Hôtel d'Angkor and Hôtel des Ruines; Angkor Wat, Kampuchea; 26

Galle Face Hotel; Colombo, Sri Lanka; 27

Hotel Imperial; New Delhi, India; 28

Great Eastern Hotel; Calcutta, India; 29

Hotel Mount Everest; Darjeeling, India; 30

Pera Palace Hotel; Istanbul, Turkey; 31

Hôtel de Paris; Paris, France; 32

Hôtel Reynolds; Paris, France; 33

Hôtel des Saints-Pères; Paris, France; 34

Hôtel Louvre et Paix; Marseille, France; 35

Hôtel Negresco; Nice, France; 36

Hôtel Métropole; Nice, France; 37

Hôtel Méditerranée; Cannes, France; 38

Hôtel Terminus; Carcassonne, France; 39

Hôtel de la Compagnie du Midi; Toulouse, France; 40

Bristol-Majestic; Monte Carlo, Monaco; 41

Hôtel de Paris; Monte Carlo, Monaco; 42

Excelsior Hotel; Rome, Italy; 43

Albergo Mediterraneo; Rome, Italy; 44

Marini Strand Hotel; Rome, Italy; 45

Hotel Flora; Rome, Italy; 46

Hotel Colombia; Genoa, Italy; 47

Hotel Subasio; Assisi, Italy; 48

Excelsior Hotel; Naples, Italy; 49

Grand Hotel Turistico; Naples, Italy; 50

Royal Victoria Hotel; Pisa, Italy; 51

Hotel Bauer Grünwald; Venice, Italy; 52

Grand Hôtel; Venice, Italy; 53

Hotel Aquila; Ortisei, Italy; 54

Parc Hotel Sole Paradiso; San Candido, Italy; 55

Grand Hotel Quisisana; Capri, Italy; 56, 57

Albergo San Domenico Palazzo; Taormina, Italy; 58

Hotel Metropol; Budapest, Hungary; 59

Hotel Erzsébet Királyné; Budapest, Hungary; 60

Hotel Lloret; Barcelona, Spain; 61

Grand Hôtel de la Paix; Madrid, Spain; 62

Hôtel Tirol; Innsbruck, Austria; 63

Grand Hôtel; Vienna, Austria; 64

Parkhotel Kärnten; Villach, Austria; 65

Hotel Excelsior; Frankfurt, West Germany; 66

Hotel Europe; Heidelberg, West Germany; 67

Badischer Hof; Baden-Baden, West Germany; 68

Hotel Trompeter-Schlosschen; Dresden, East Germany; 69

Excelsior Hotel Ernst; Cologne, West Germany; 70

Coblenzer Hof; Koblenz, West Germany; 71

Park Hotel; Bremen, West Germany; 72

Hotel Schwarzer Bock; Wiesbaden, West Germany; 73

Hôtel Belvédère; Furka Pass, Switzerland; 74

Hotel Schweizerhof; Zermatt, Switzerland; 75

Beau-Rivage Palace-Hotel; Lausanne-Ouchy, Switzerland; 76

Regina Hôtel Jungfraublick; Interlaken, Switzerland; 77

Carlton Hôtel; Lucerne, Switzerland; 78

Hôtel des Bergues; Geneva, Switzerland; 79

Hotel Rigi-Kulm; Rigi-Kulm, Switzerland; 80

Hotel Pilatus-Kulm; Mt. Pilatus, Switzerland; 81

Hotel Monte Rosa; Zermatt, Switzerland; 82

Grand Hôtel des Alpes; Mürren, Switzerland; 83

Hotel Excelsior; Zurich, Switzerland; 84

Hôtel Baur au Lac; Zurich, Switzerland; 85

Villars Palace; Villars, Switzerland; 86

Hôtel Seeland; Biel, Switzerland; 87

Grosvenor House; London, England; 88

Kensington Palace Hotel; London, England; 89

Fircroft Hotel; Bournemouth, England; 90

Grand Pump-Room Hotel; Bath, England; 91

Hotel Pension Noordzee; Noordwijk aan Zee, The Netherlands; 92

Victoria Hotel; Amsterdam, The Netherlands; 93

Grand Hotel-Central; The Hague, The Netherlands; 94

Egmont Hotel; Copenhagen, Denmark; 95

Hôtel Grande Bretagne; Athens, Greece; 96

Majestic Hotel; Alexandria, Egypt; 97

Windsor Hotel; Cairo, Egypt; 98

Louxor Hotel; Luxor, Egypt; 99

Shepheard's Hotel; Cairo, Egypt; 100

Louxor Winter Palace; Luxor, Egypt; 101

Hotel Fast; Jerusalem, Israel; 102

Hôtel St. Georges; Beirut, Lebanon; 103

Hôtel Transatlantique; Bou Saâda, Algeria; 104

Hôtel du Caïd; Bou Saâda, Algeria; 105

Grand Hôtel; Tunis, Tunisia; 106

Hôtel Excelsior; Casablanca, Morocco; 107

The Australia Hotel; Sydney, Australia; 108

The Brisbane Hotel; Launceston, Australia; 109

City Hotel; Buenos Aires, Argentina; 110

Mendoza's; Ciudad Juarez, Mexico; 111

Hotel Regis; Mexico City, Mexico; 112

Hotel Alexandria; Los Angeles, United States; 113

Will Rogers Hotel; Claremore, United States; 114

Hotel Adolphus; Dallas, United States; 115

Pioneer Hotel; Tucson, United States; 116

Hotel Victoria; New York, United States; 117

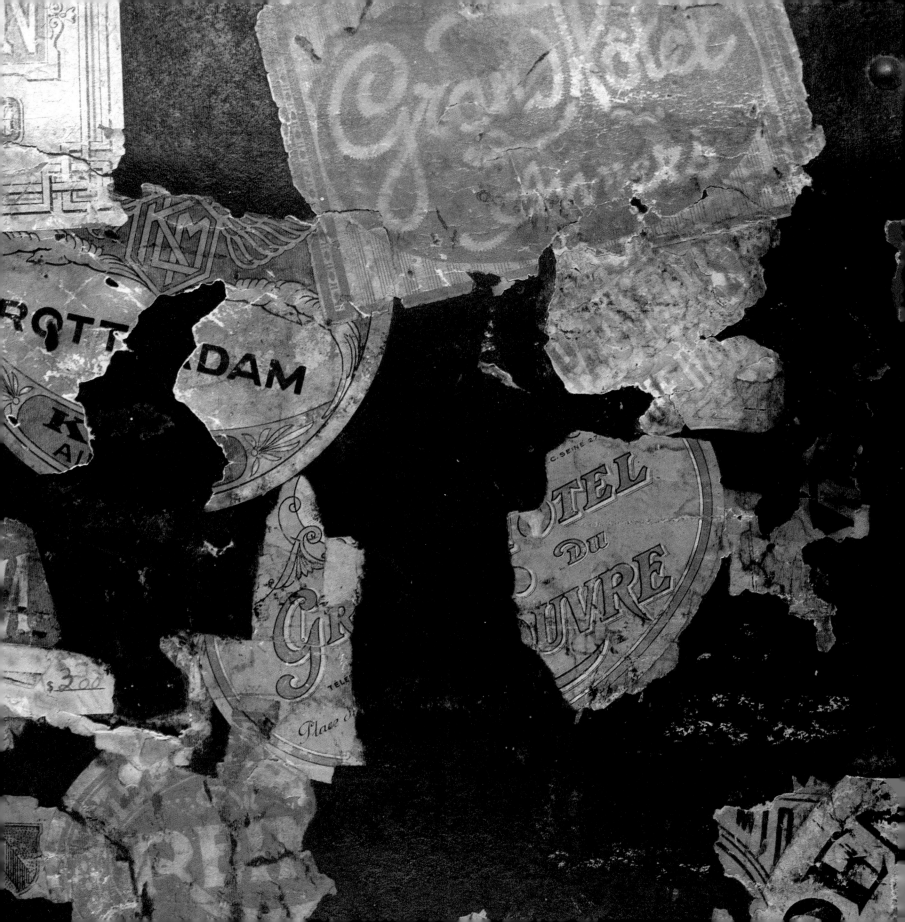